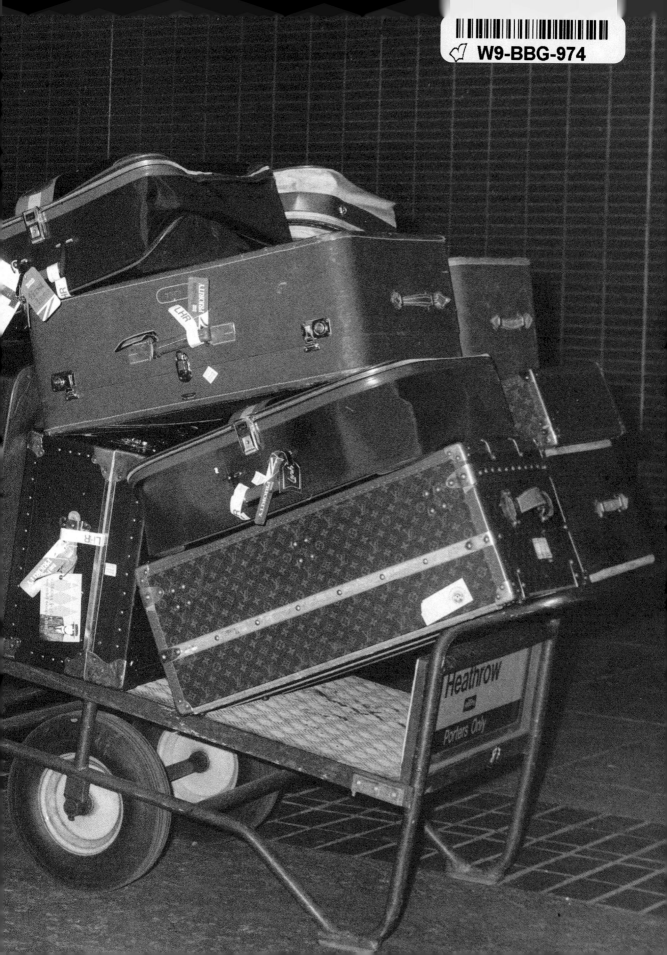

COME FLY WITH ME

COME FLY WITH ME
Flying in Style

Jodi Peckman

RIZZOLI NEW YORK

New York · Paris · London · Milan

Believe me when I tell you there was once a magical time when taking a trip on an airplane was glamorous—for everyone. There was indeed an era when ordinary humans arrived at the airport in suits and dresses; when passengers didn't have to yank off their shoes at security; when you didn't sit wedged into seat 35F paranoid about the sneezes of the barefoot schnook in 36E. Dinner was served with a fork and knife. Downtime was a cigarette and vodka in a glass. The flight didn't have wi-fi, but it had seductiveness. If you got bored, you could simply look out the window and gaze down at all that endless landscape and possibility. And then have another cigarette and vodka.

Flying isn't the least bit stylish anymore, except for one elevated category of human: celebrities. For the famous, air travel retains trace elements of the old, escapist fantasy, even for those flying commercial instead of aboard G6s. A celebrity's voyage through the airport remains an enduring ritual of fame: the star who has (or hasn't) taken steps to avoid recognition; the dodging (or courting) of the paparazzi, who almost always have been tipped off in advance; the inevitable rubbernecking of the rest of us. Is that...? No, it can't be. It is...

And the clothes! Celebrity airport fashion can be considered a genre unto itself: an endlessly evolving mixture of high and low couture, bags, jewelry, dogs, and, of course, dark, face-smothering sunglasses—especially at night. A good celebrity airport photo should offer style and hints of mystery and mood.

Where'd they get that hat? What's in that bag? Are they happy? Are they devastated? Maybe the celebrity is fresh off a scandal, a breakup, or a bender. (Maybe the bender is still happening... hence the sunglasses.)

Jodi Peckman gets this. She has made a career out of orchestrating iconic photography, a life that has often found her racing through (or marooned in) airports around the world. Though the shoots Peckman oversees herself are often elaborate, she has long admired the serendipity of a simple airport photograph, taken in a flash. Come Fly With Me is her hand-edited celebration of this form, spanning several generations of travel and fame. There's Muhammad Ali in an impeccable cream suit, carrying a slim briefcase; there's Prince in a double-breasted windowpane suit; there's Paul Newman, in a turtleneck, carrying a cord-wrapped box of indeterminate contents. There's Dolly Parton, high-kicking at baggage claim. Then there are the couples—the ultimate sightings in the airport celebrity wilderness. There's John and Yoko, Serge and Jane, Ali and Bob. Oh, to be young and in love and seated next to each other in first class...

Come Fly With Me is a joyous compendium of largely under-appreciated photography that doubles as a rollicking history of celebrity, travel, and fashion, from the days when Marilyn Monroe disembarked in fur to when Justin Bieber arrived in sweatpants and a baseball cap. It's both a warm blast of nostalgia and a reminder that celebrity still has the power to captivate. Flipping through its pages may make you want to buy new luggage, fresh sunglasses, and, perhaps, a teacup poodle. In the end, you'll realize that Jodi Peckman has done the impossible: she's returned some romance to the sky.

Once, while looking through thousands of images for a section of Rolling Stone Magazine called "Random Notes," I came across a photograph of Mary-Kate and Ashley Olsen. It stopped me in my tracks.

Long fascinated by photos of celebrities at airports, this image instantly became my favorite and I added it to my collection. It appears to be just another paparazzi shot solely intended for sale to the tabloids, but there is a depth beyond the initial exterior. Its solid, amorphous shape captures the essence of these girls—twins, who seem to move through life as one unit, constantly dodging the cameras that stalk them. We can't see them, but we know who they are.

My interest in these kinds of images started with a photo of Paul and Linda McCartney arriving at the airport in the early 1970s. I loved everything about it. A look at a famous family in such a public space, they seem so natural. They are not posing, they don't look overly self-conscious, and their style is terrific.

In fact, all these photographs I've collected have incredible style. For me it's an interesting, unique way to look at fashion through the last fifty years. Whether the subjects are strutting through the terminal as if in a runway show or consciously masking themselves from the paparazzi, all of them have a style that falls somewhere between sophistication and chaos, glamor and spontaneity—and that is timeless.

Lady Gaga
LAX, 2015

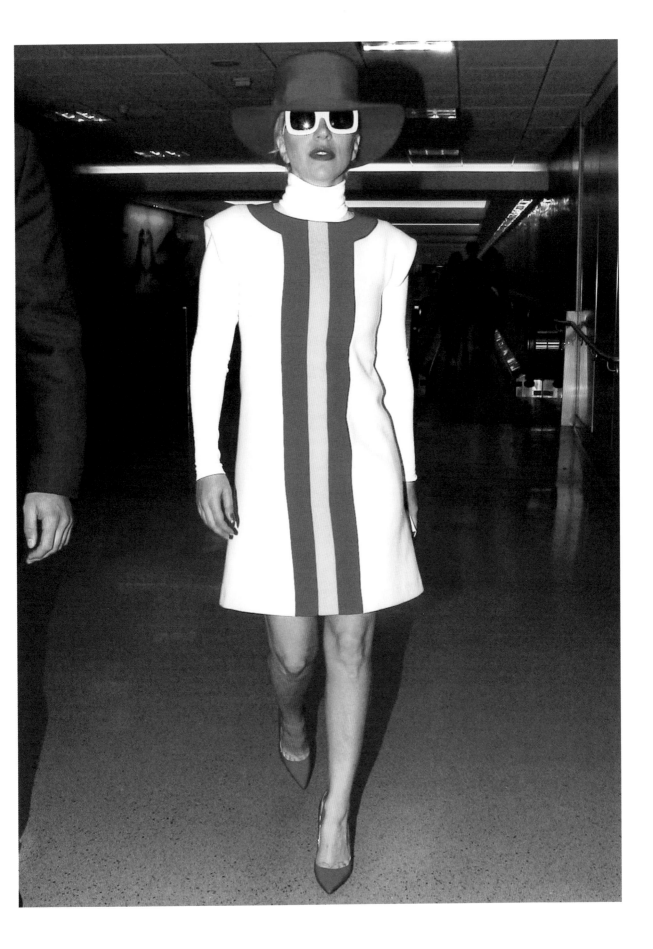

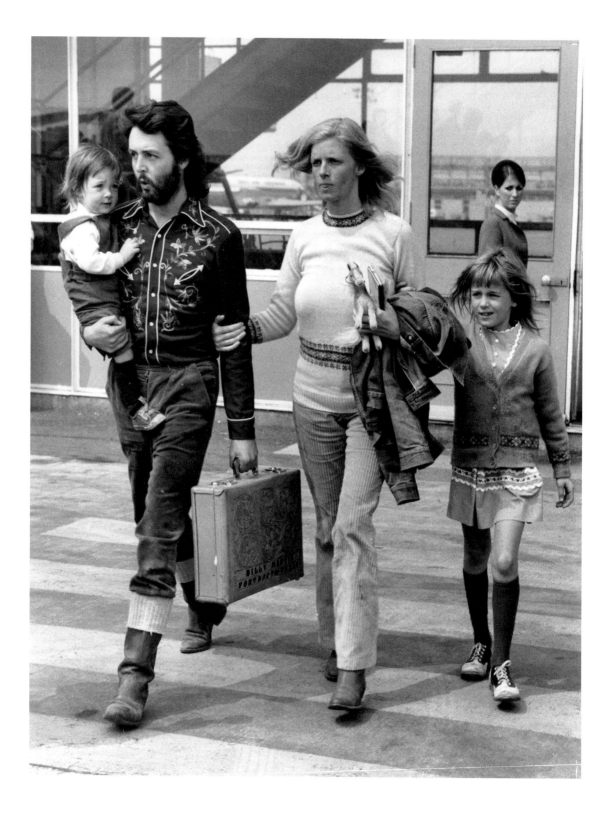

Paul and Linda McCartney
LGW, 1971

Frank Zappa
LHR, 1975

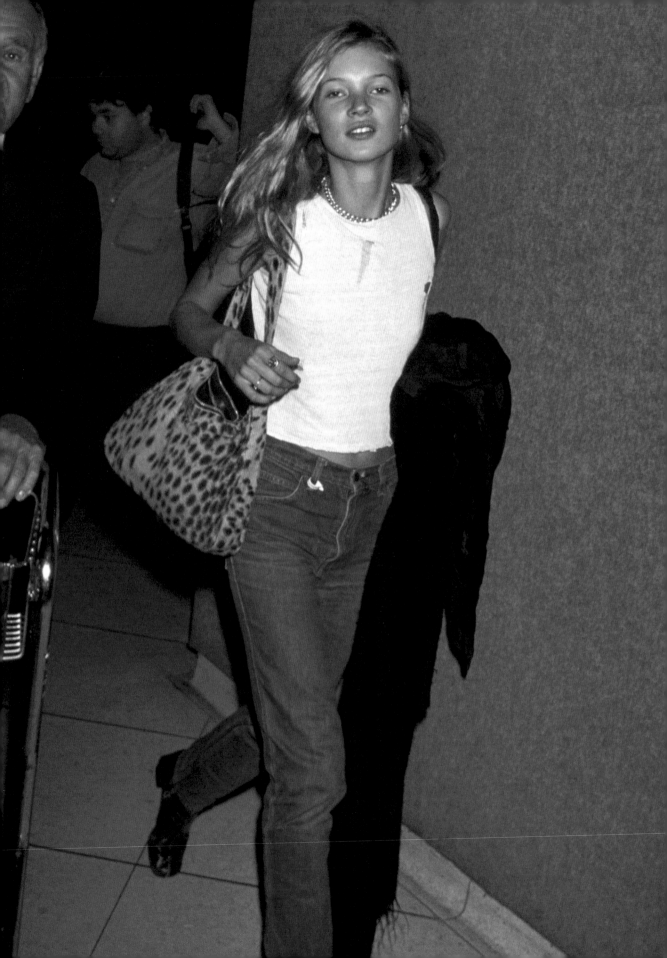

Little Richard
LCY, 1972

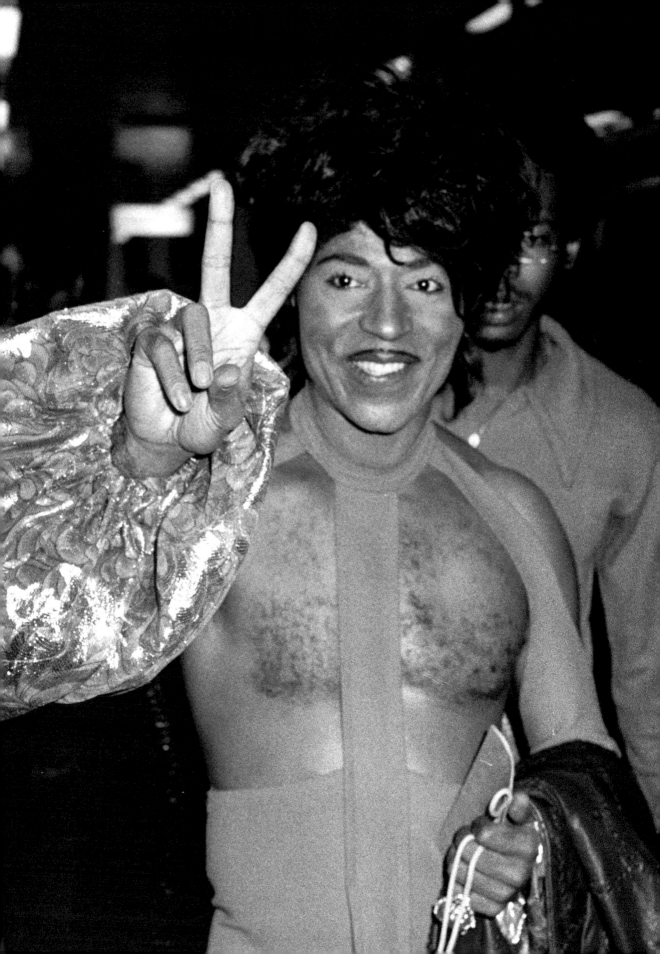

Miley Cyrus
SYD, 2014

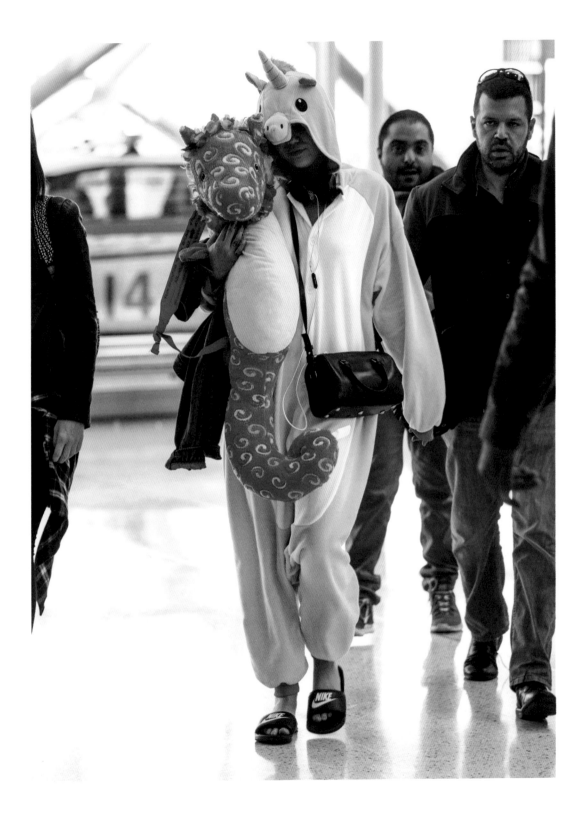

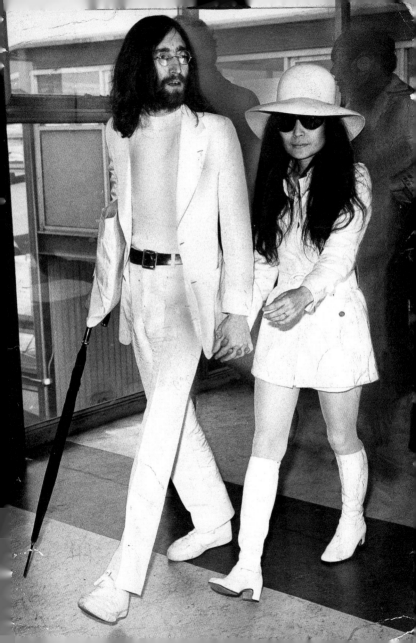

John Lennon and Yoko Ono
LCY, 1969

Marlon Brando
ORY, 1959

A good photograph was never what I was looking for. I like to have a point. This is what I've always found so fascinating about paparazzi pictures. They catch something unintended, on the wing... they get that thing. It's the revelation of personality.

—Diana Vreeland

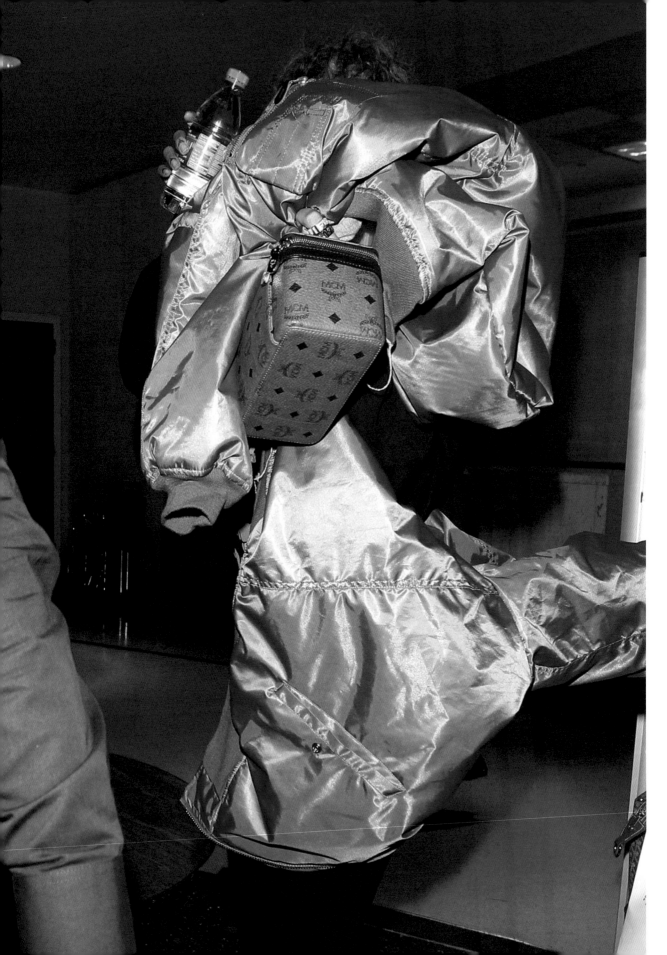

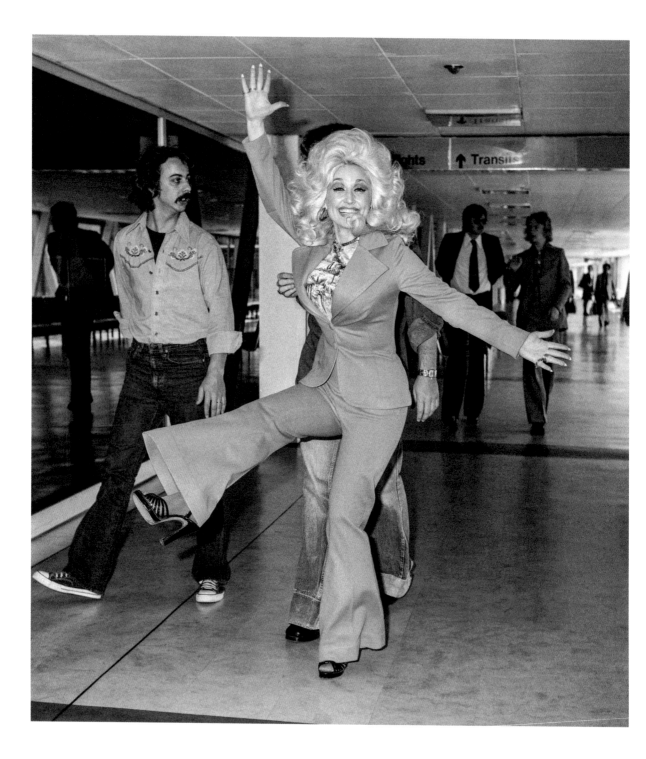

Dolly Parton
LHR, 1976

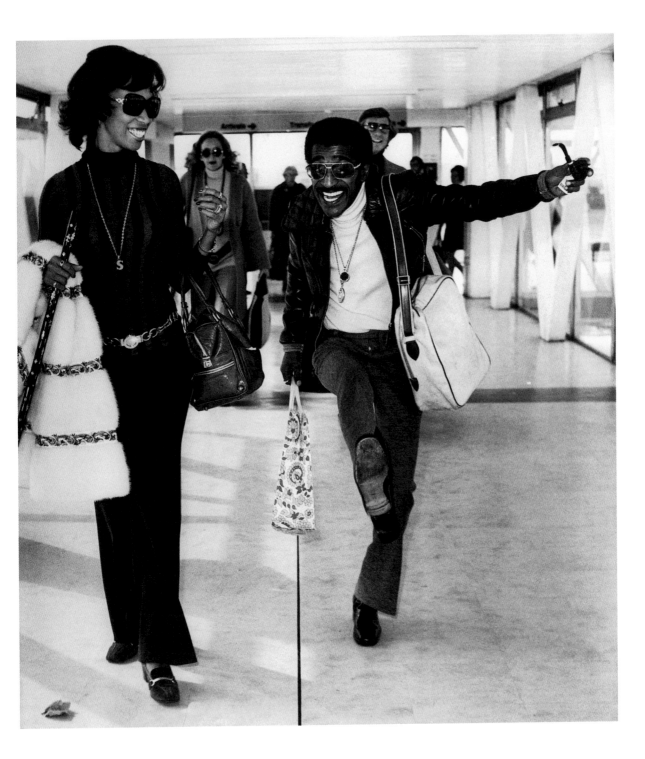

Sammy Davis Jr.
LHR, 1972

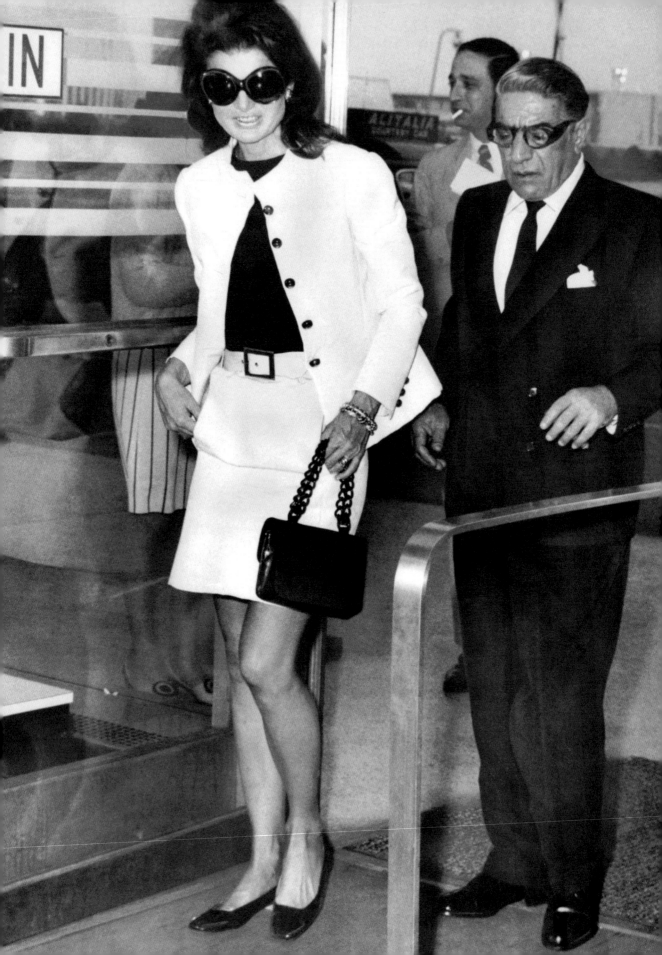

Jackie and Aristotle Onassis
JFK, 1969

Winona Ryder
LAX, 1990

Airports in major cities, like LAX, are trippy environments. It is at once a national and international gathering of those in transition: The euphoric, emerging from planes, their journey at an end, and the determined, about to depart.

— Henry Rollins

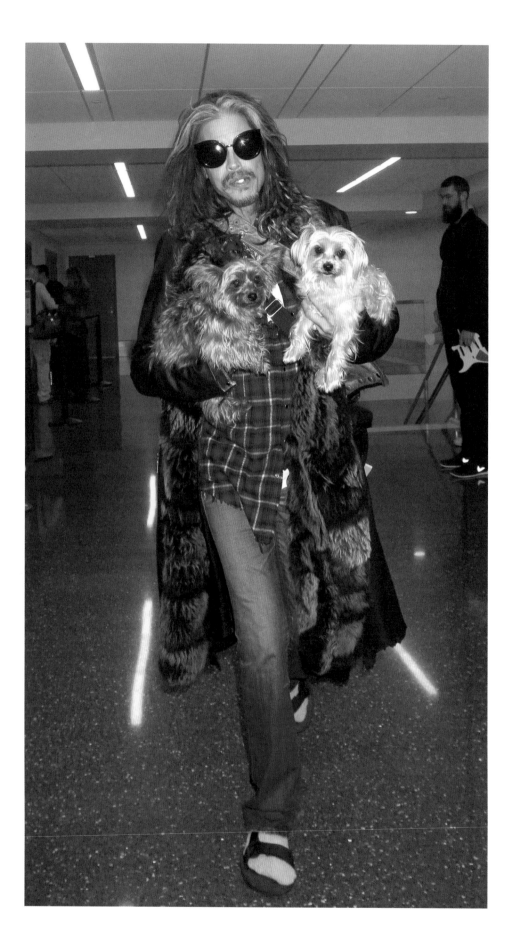

Steven Tyler
LAX, 2016

Joan Rivers
LAX, 1996

Mick Jagger and Marianne Faithfull
LCY, 1969

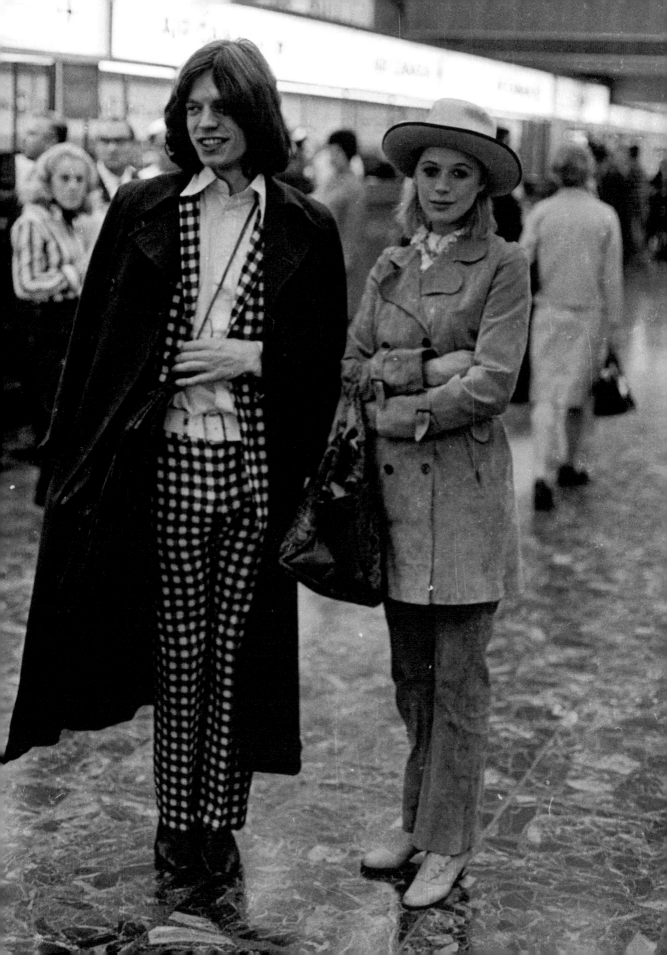

Joan Collins
LHR, 1989

Johnny Depp
NRT, 2018

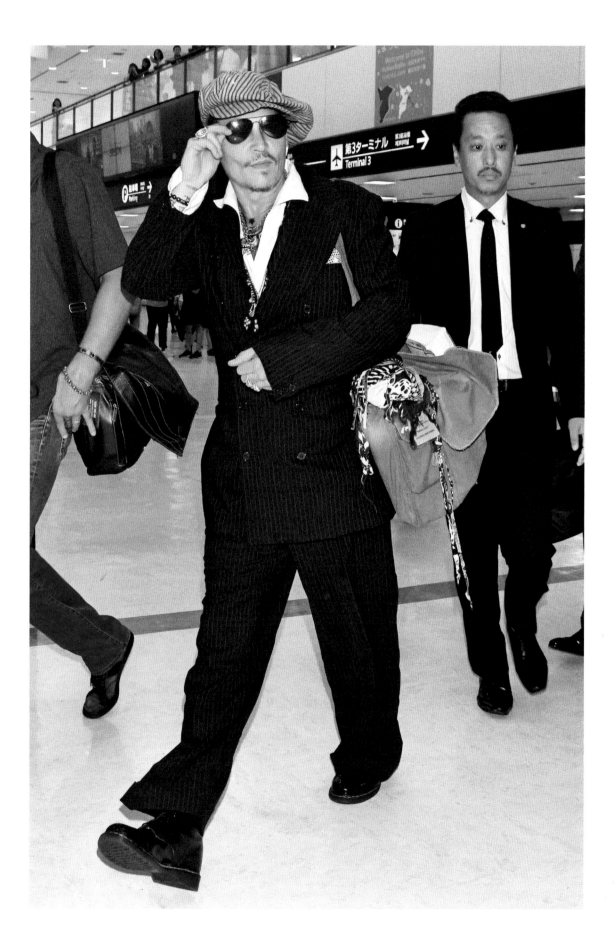

Muhammad Ali
LHR, 1967

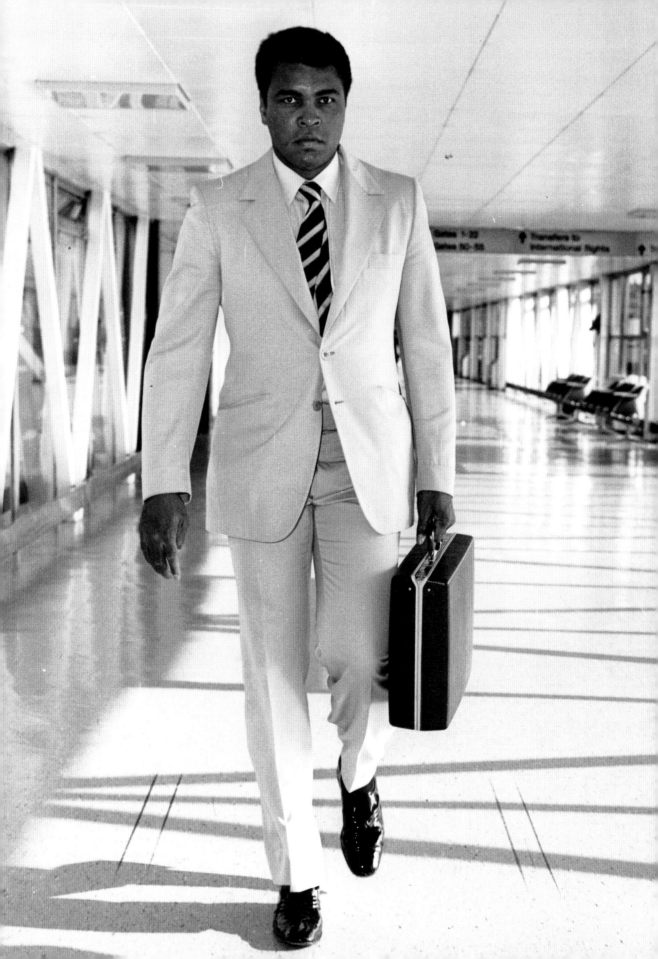

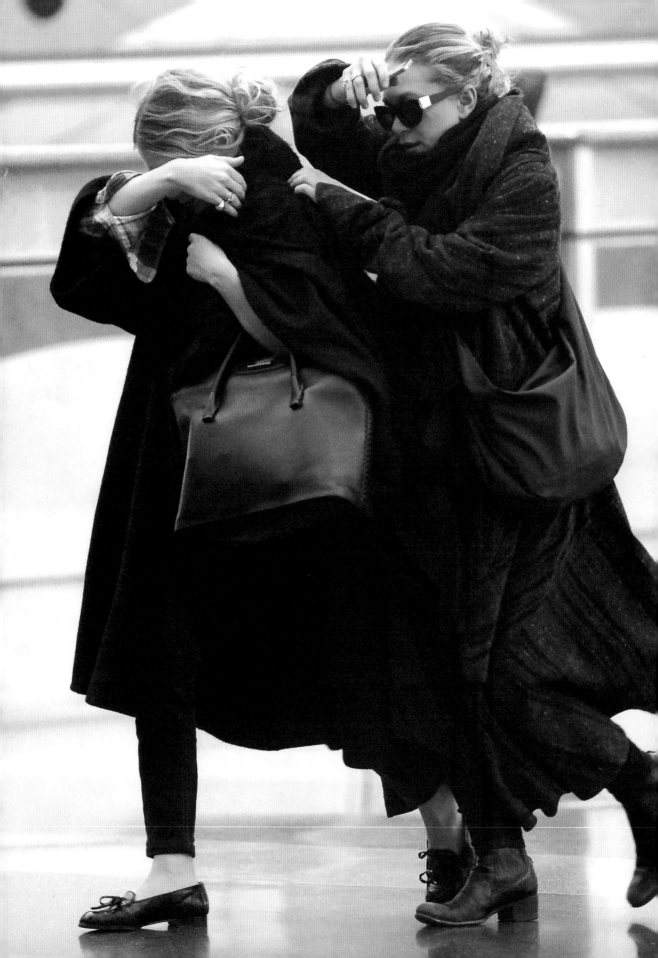

Mary-Kate and Ashley Olsen
LAX, 2014

Dean Martin and Frank Sinatra
LCY, 1961

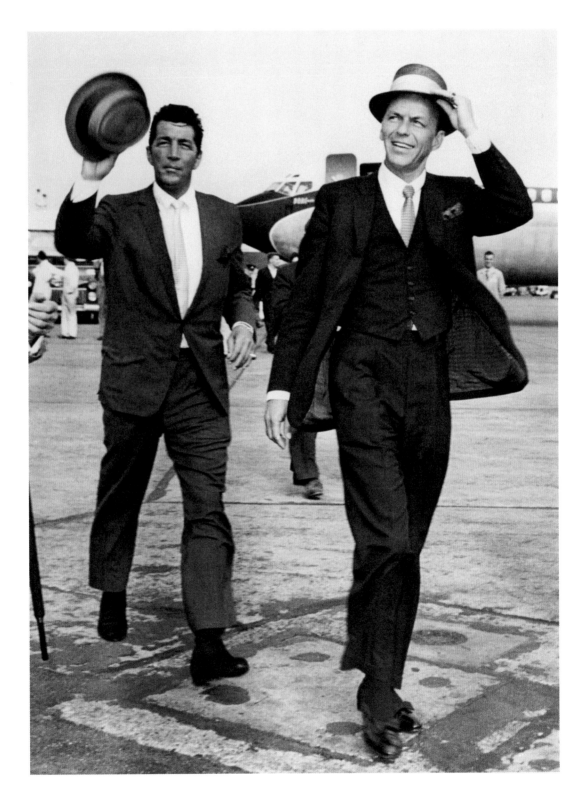

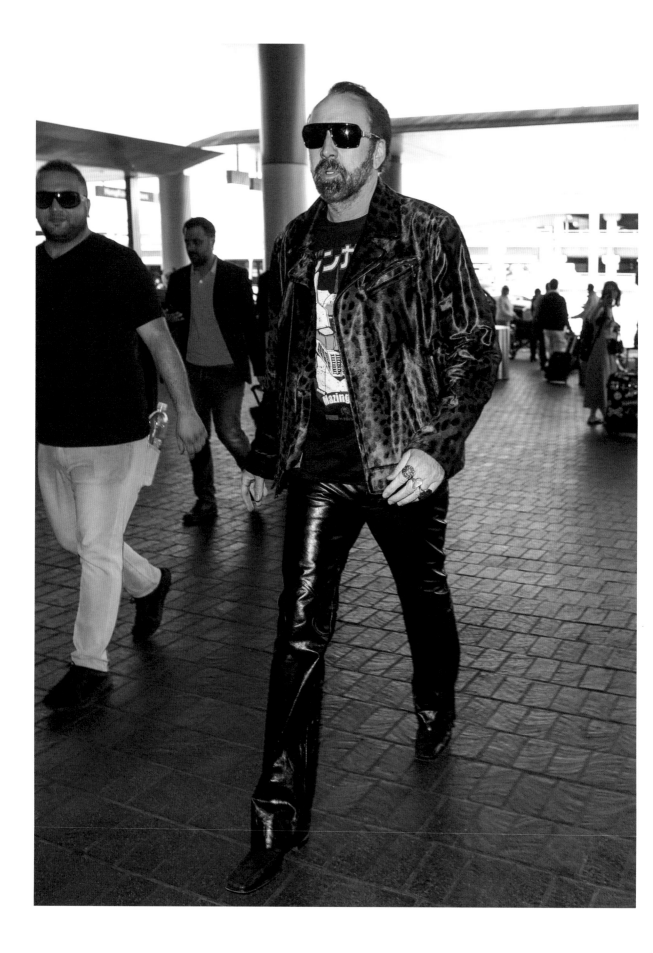

Nicolas Cage
LAX, 2018

Naomi Campbell
LBG, 1998

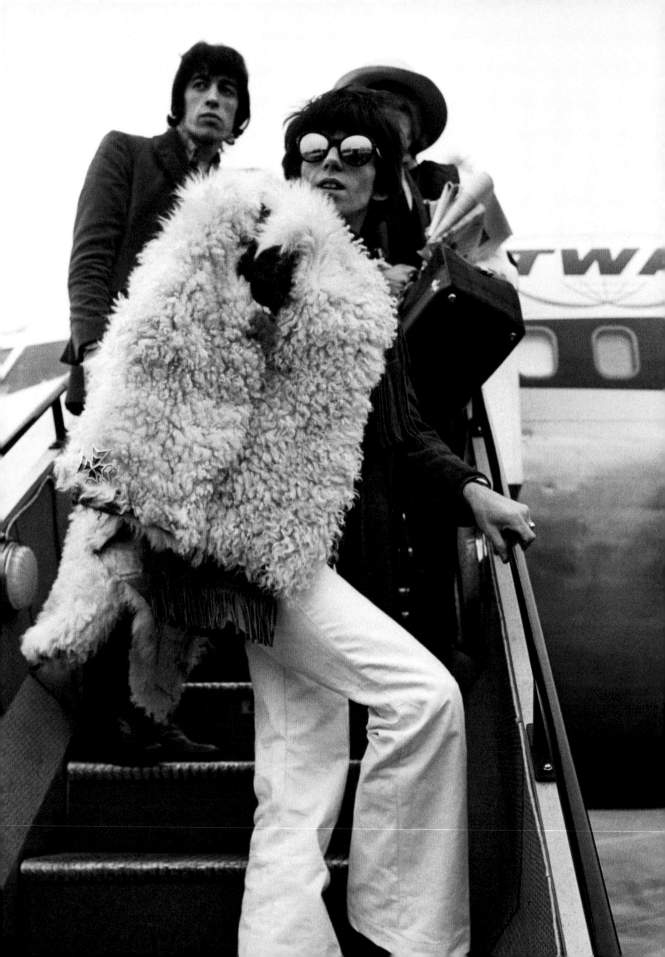

The Rolling Stones
LHR, 1967

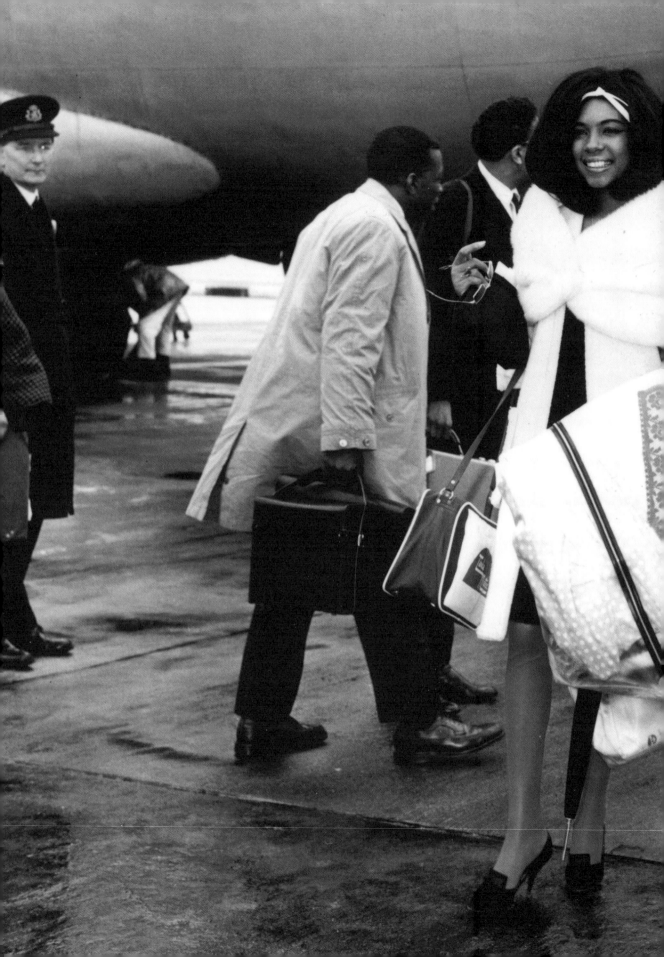

The Supremes
LHR, 1965

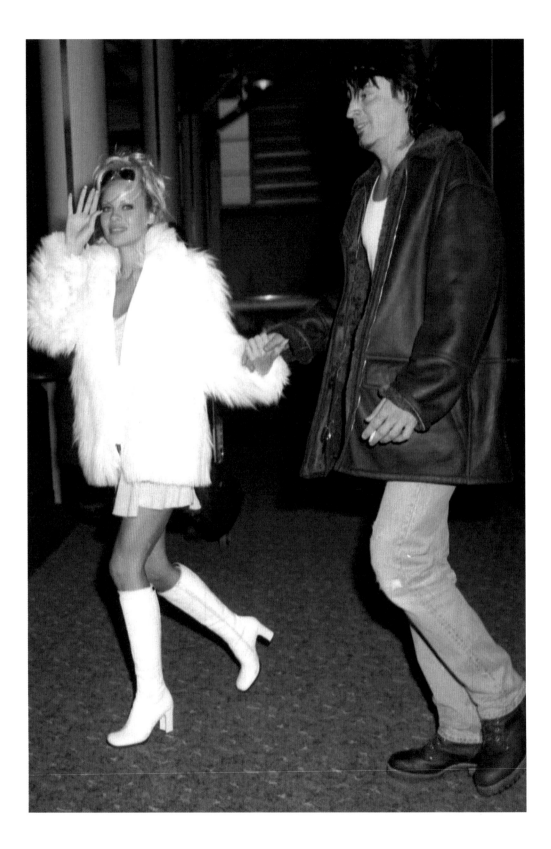

Pamela Anderson and Tommy Lee
LHR, 1995

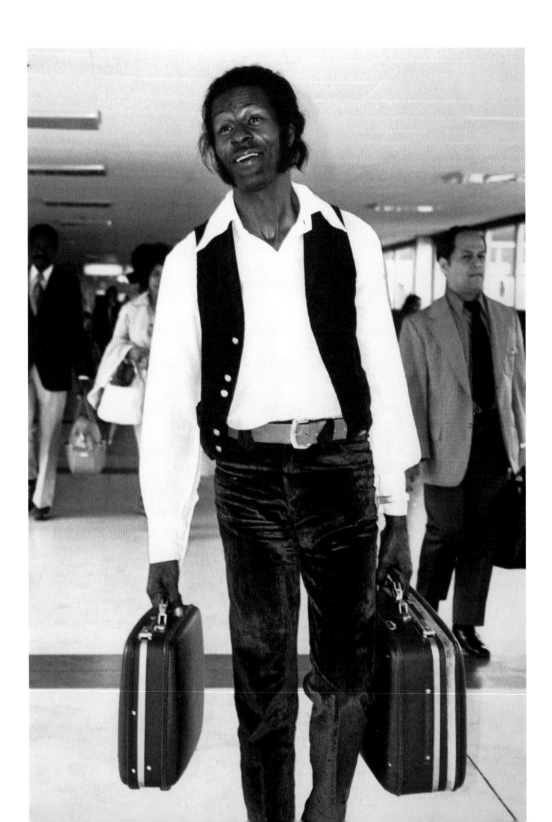

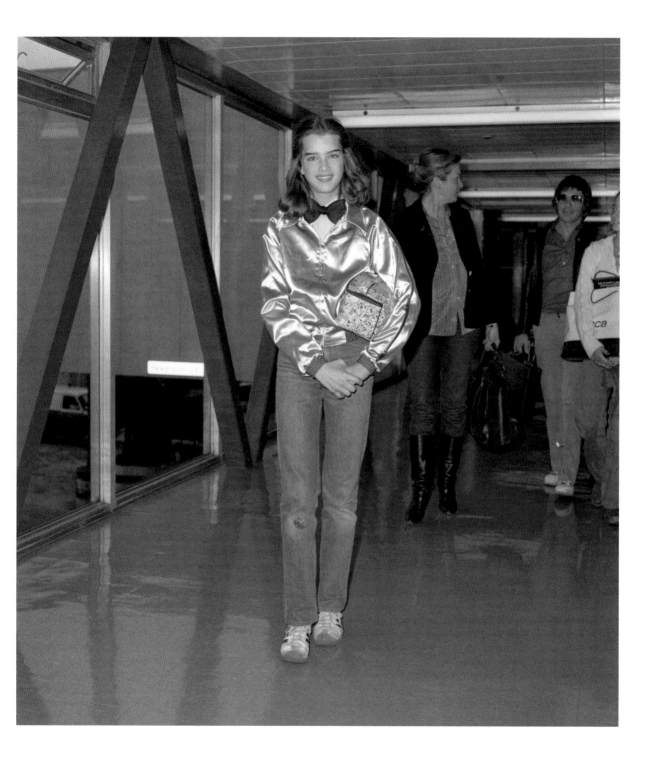

Chuck Berry
LHR, 1972

Brooke Shields
LHR, 1978

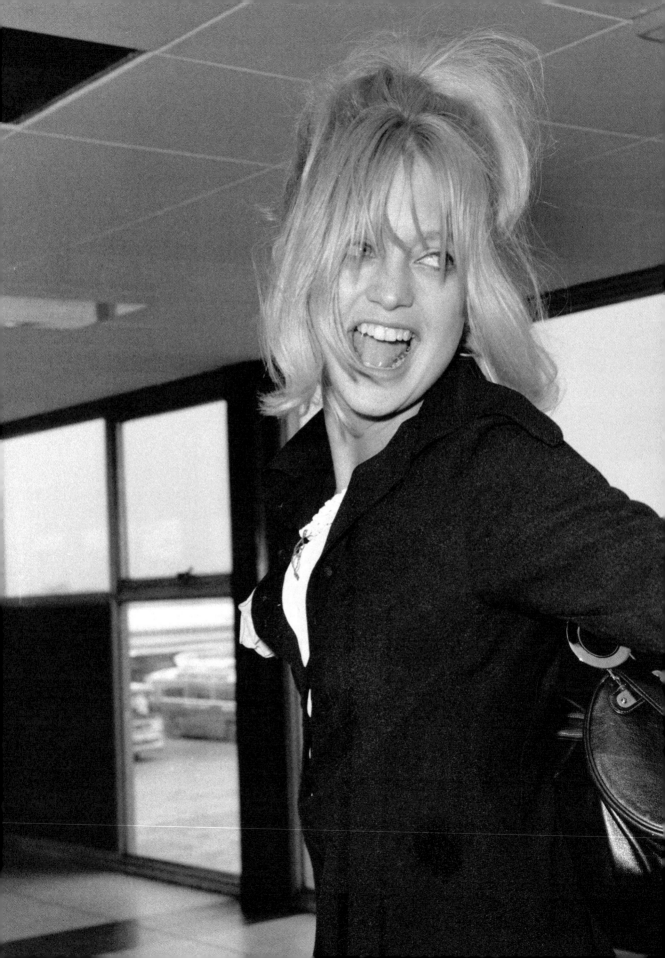

Goldie Hawn
LHR, 1970

55

Brigitte Bardot
LHR, 1968

Warren Beatty
IAD, 1977

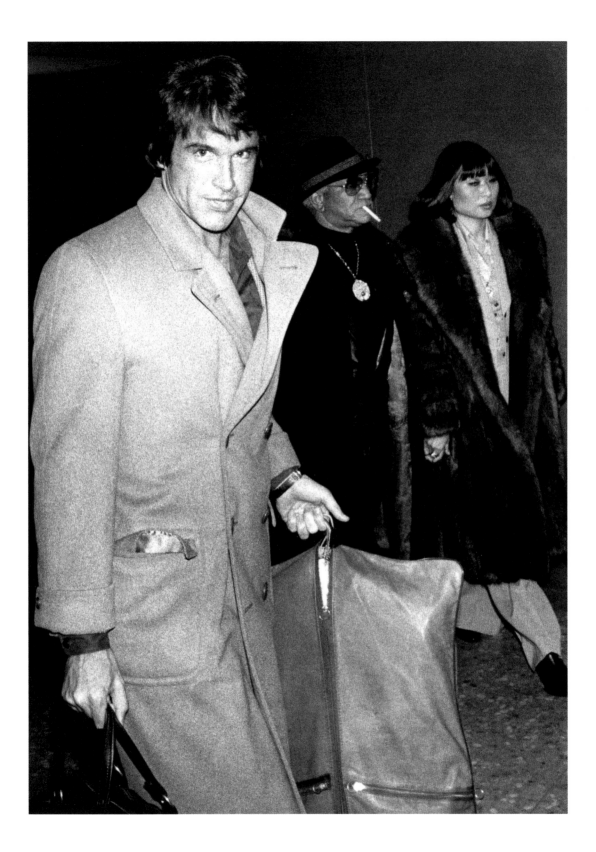

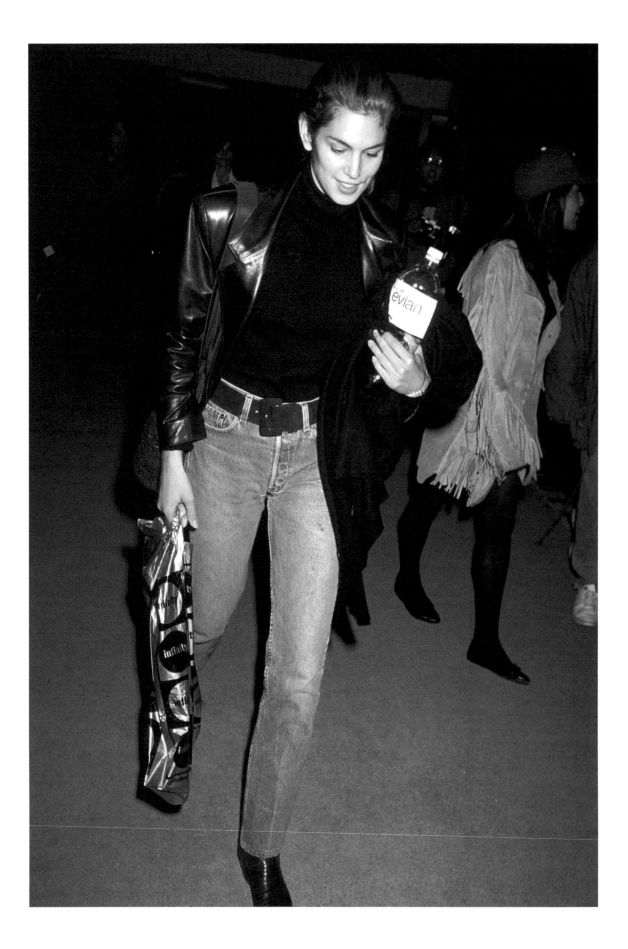

Cindy Crawford
LAX, 1991

Elton John
LHR, 1982

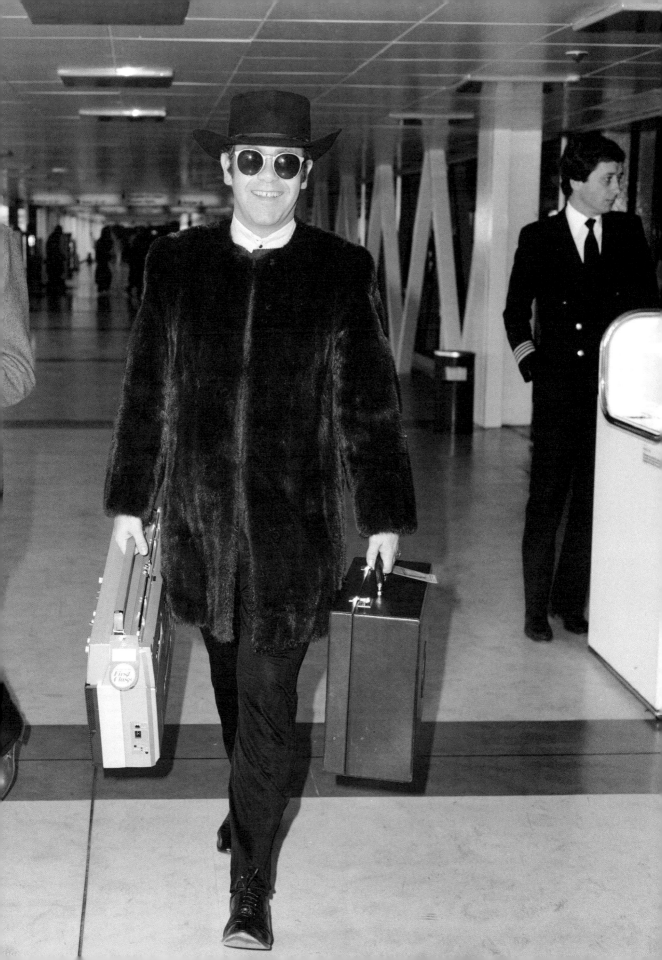

Jane Fonda
JFK, 1962

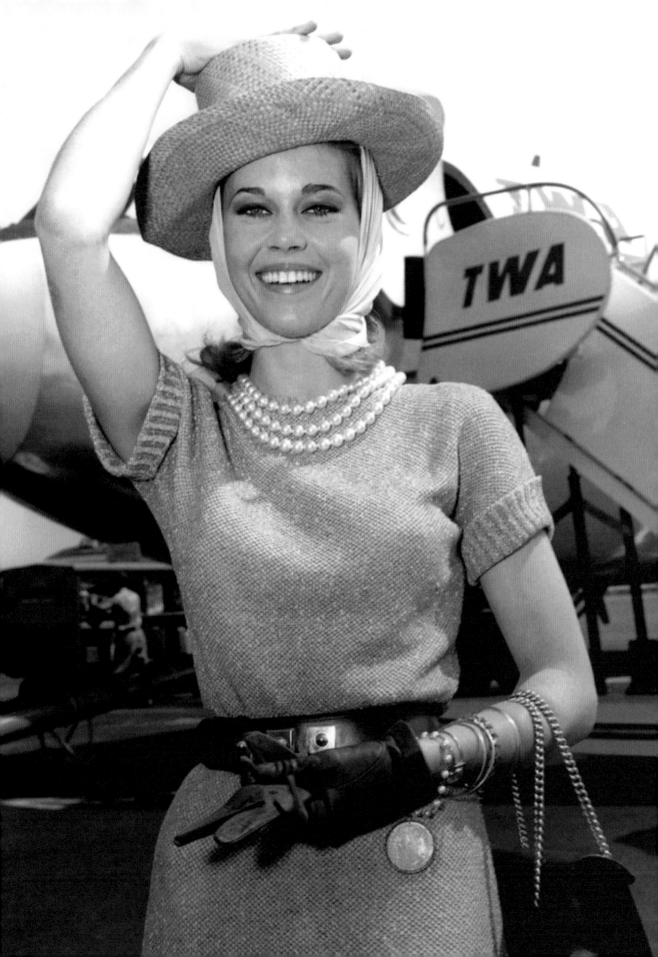

Anywhere I go, there is always an incredible crowd that follows me. In Rome, as I land at the airport, even the men kiss me.

—Muhammad Ali

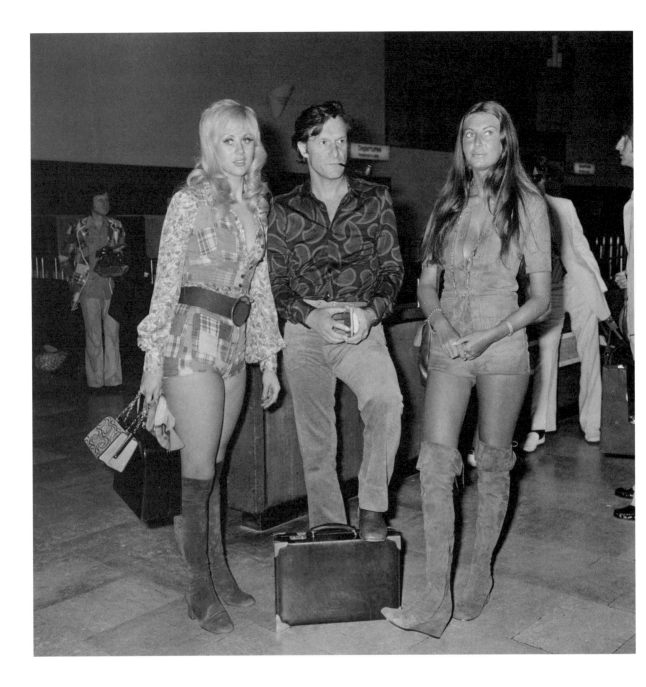

Rosamund Teller, Hugh Hefner, and Marilyn Cole
LHR, 1971

Sonny Bono and Cher
HAM, 1966

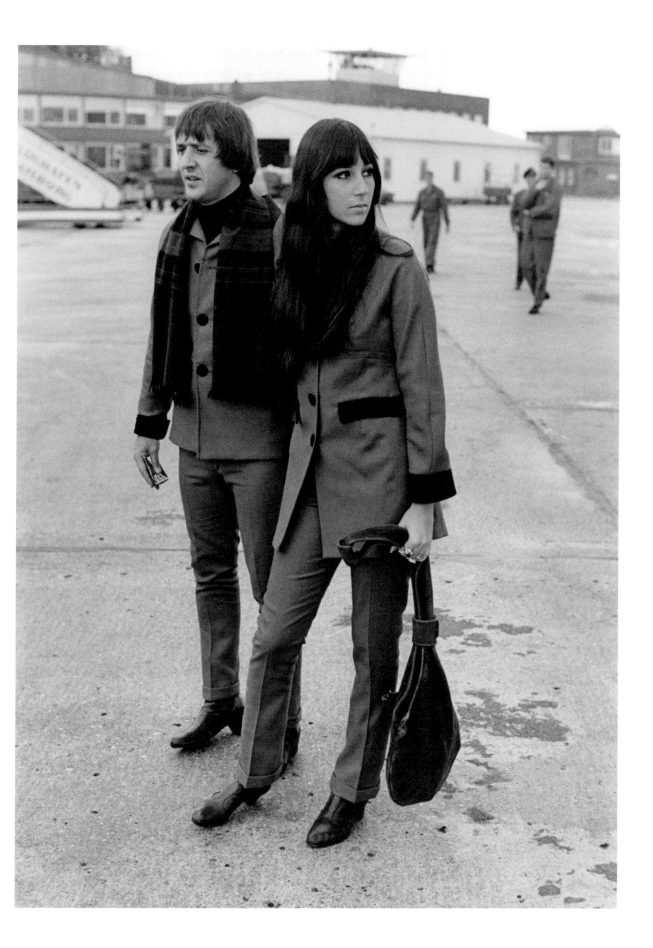

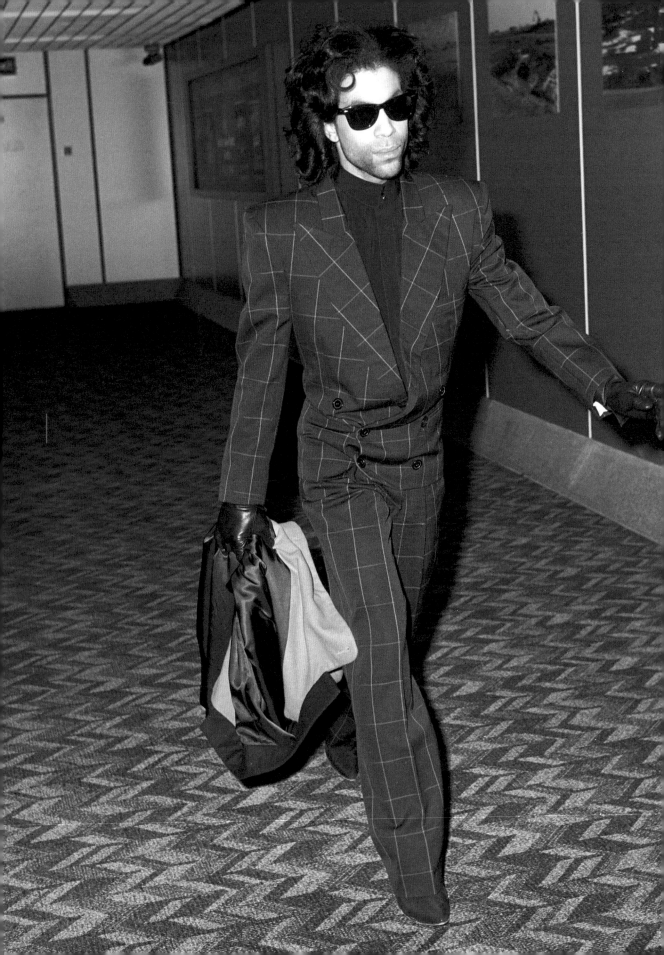

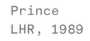

Prince
LHR, 1989

Michael Jackson
LHR, 1996

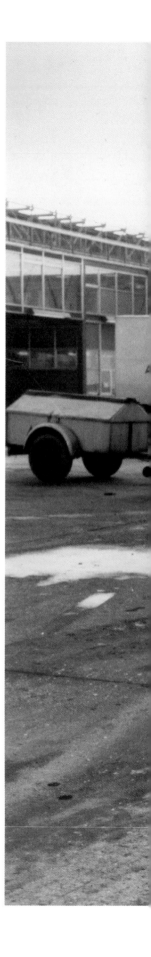

Maharishi Mahesh Yogi and Mia Farrow
LCY, 1968

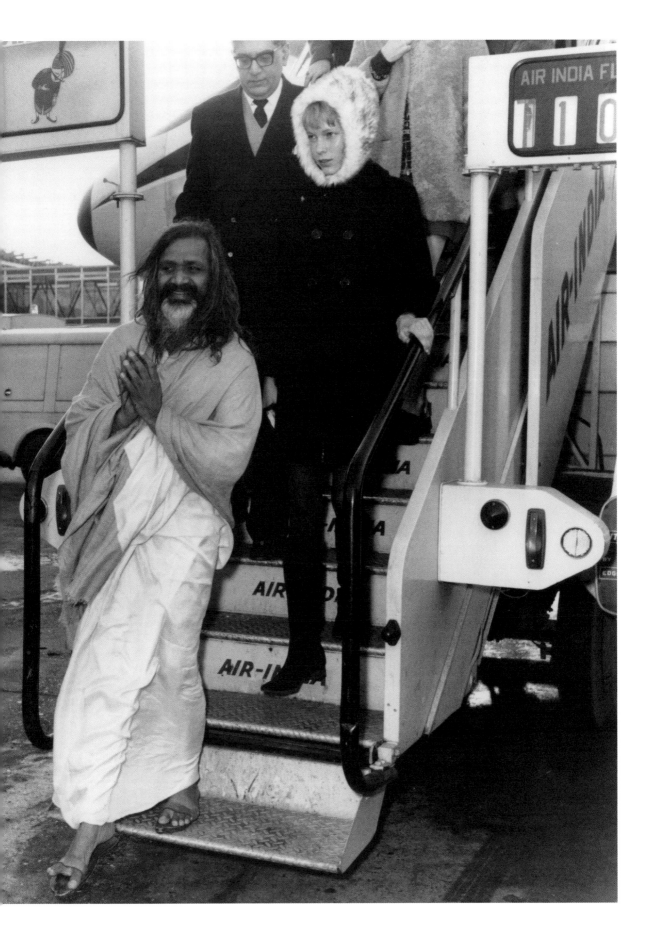

Liza Minelli
LHR, 1969

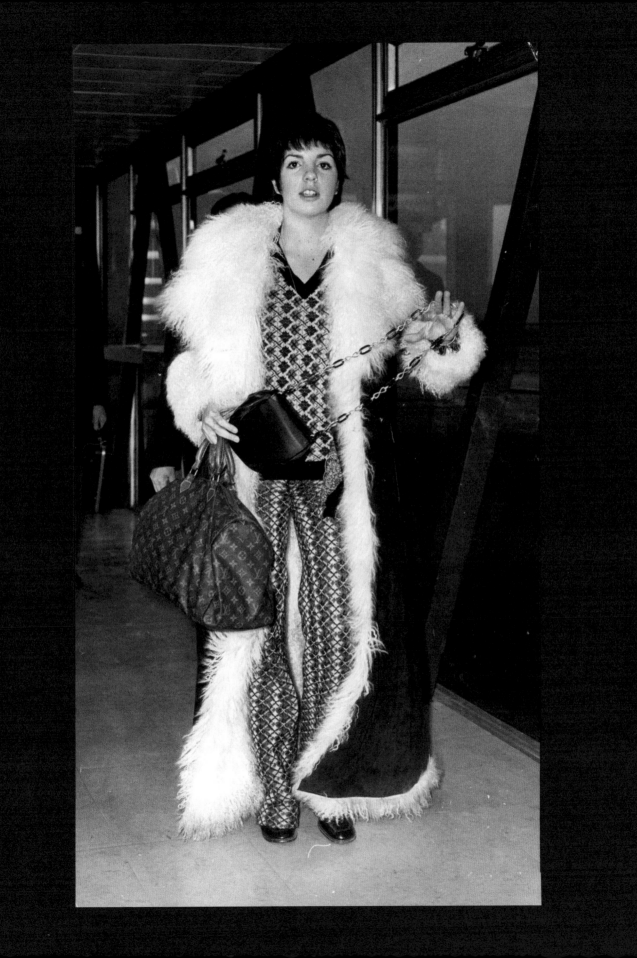

Brigitte Bardot
LHR, 1967

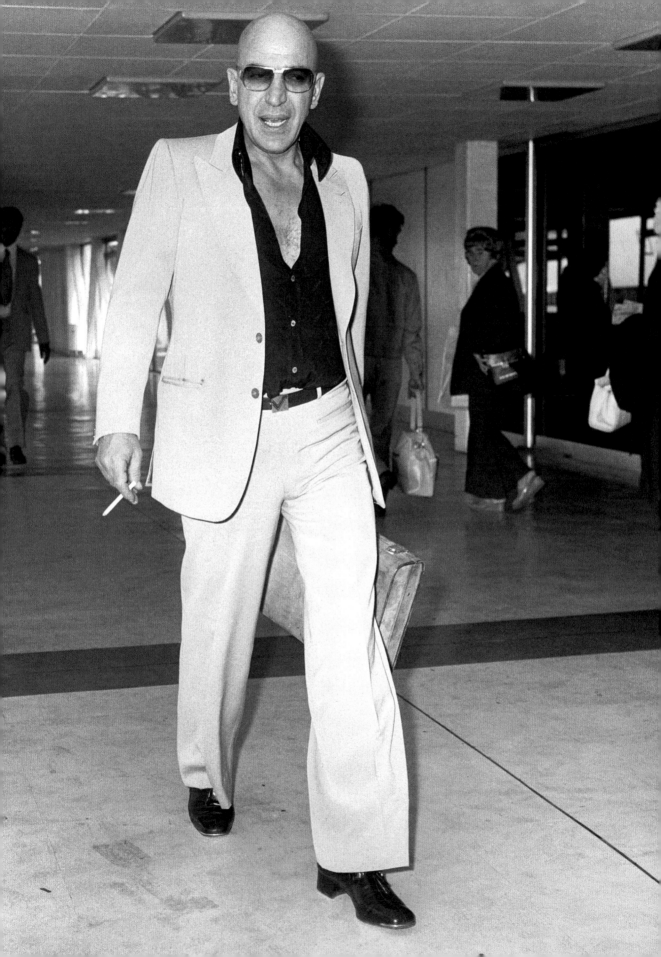

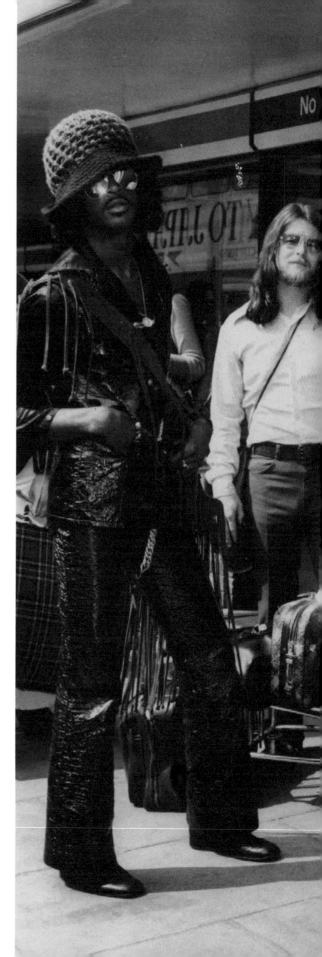

Sly and the Family Stone
LHR, 1970

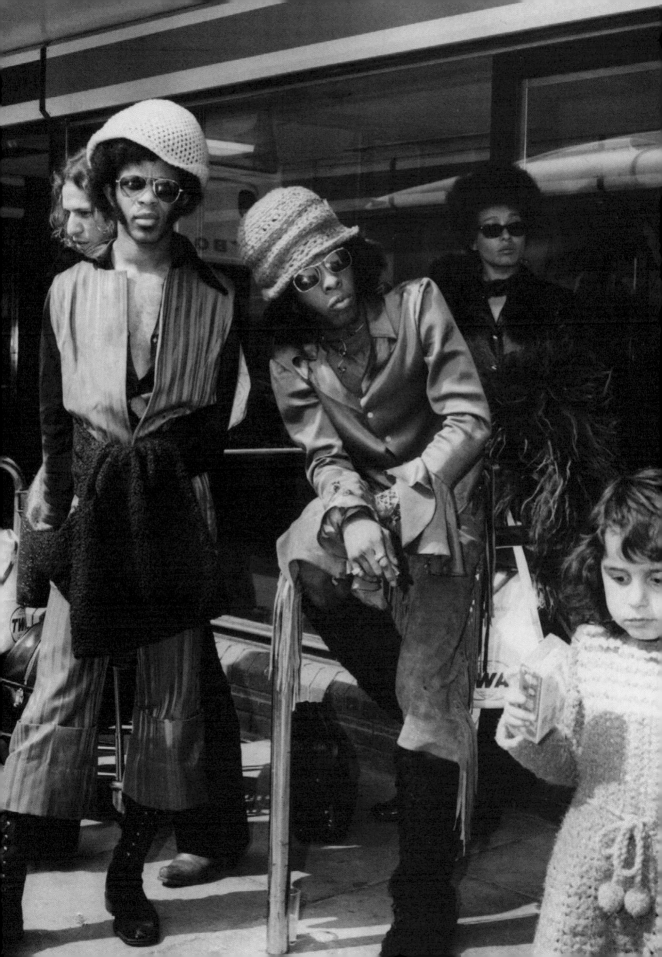

Madonna
JFK, 2013

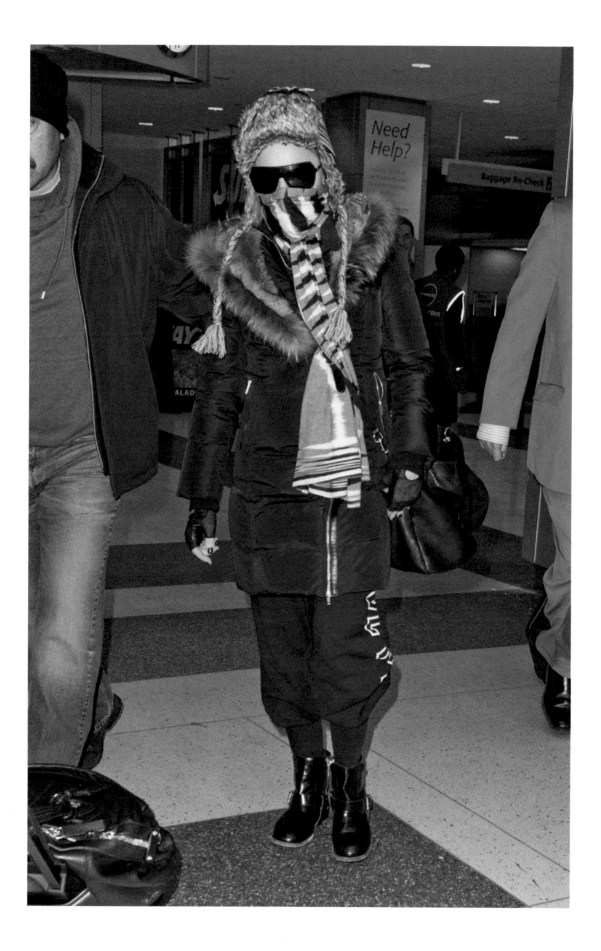

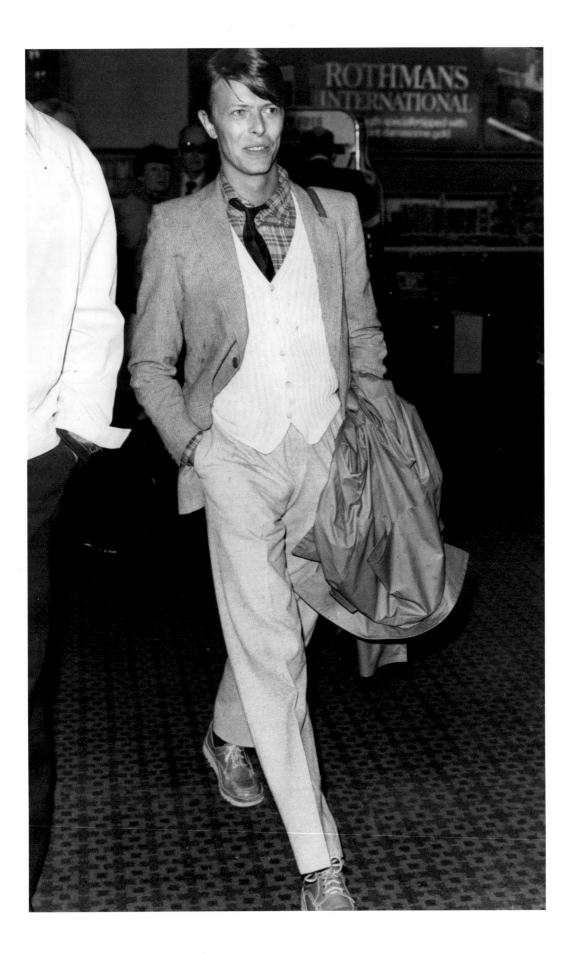

David Bowie
LHR, 1978

Elizabeth Taylor and George Hamilton
LHR, 1986

Imagine if every airport would blast Brian Eno. I bet going through security wouldn't be as difficult. I can't imagine someone being aggressive with me with Brian Eno music pumping through the terminals at LAX.

—Parker Posey

Ali McGraw and Robert Evans
FCO, 1971

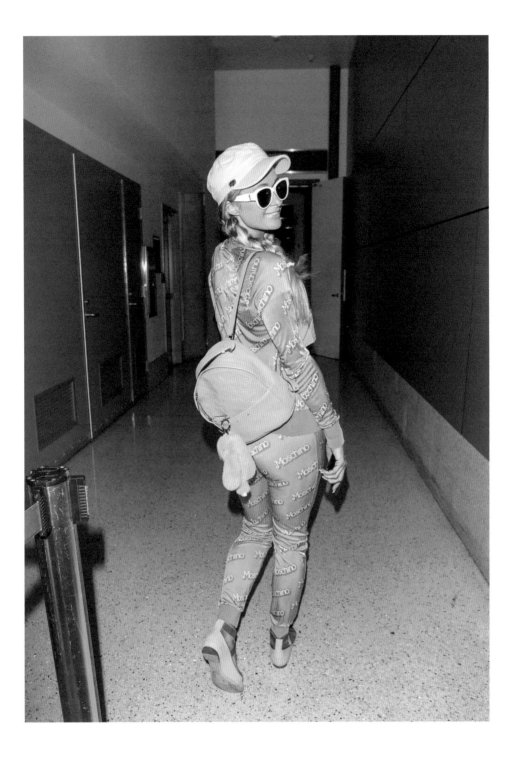

Paris Hilton
LAX, 2018

Kim Kardashian
BUR, 2007

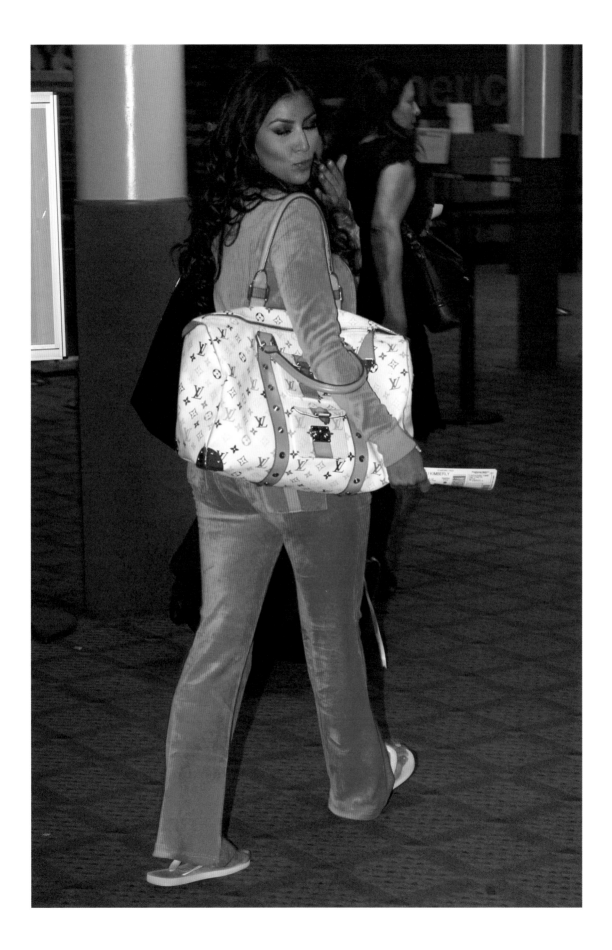

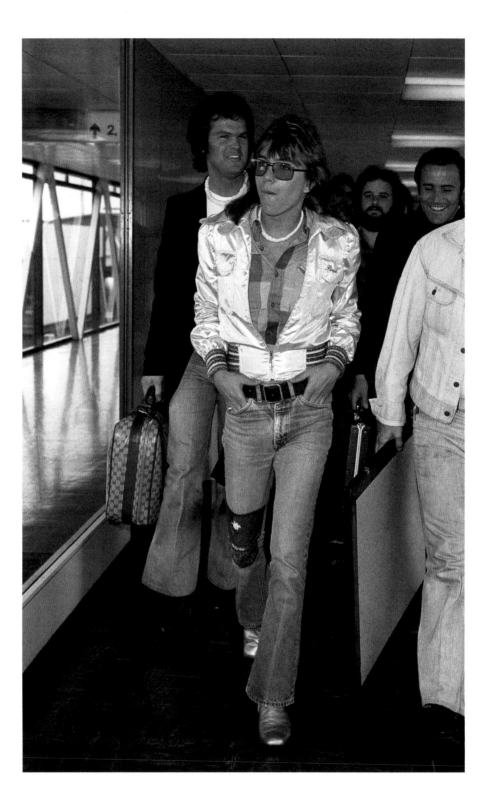

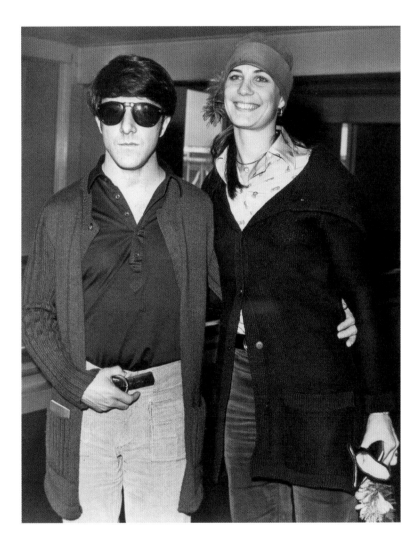

David Cassidy
LHR, 1974

Dustin and Anne Hoffman
LHR, 1972

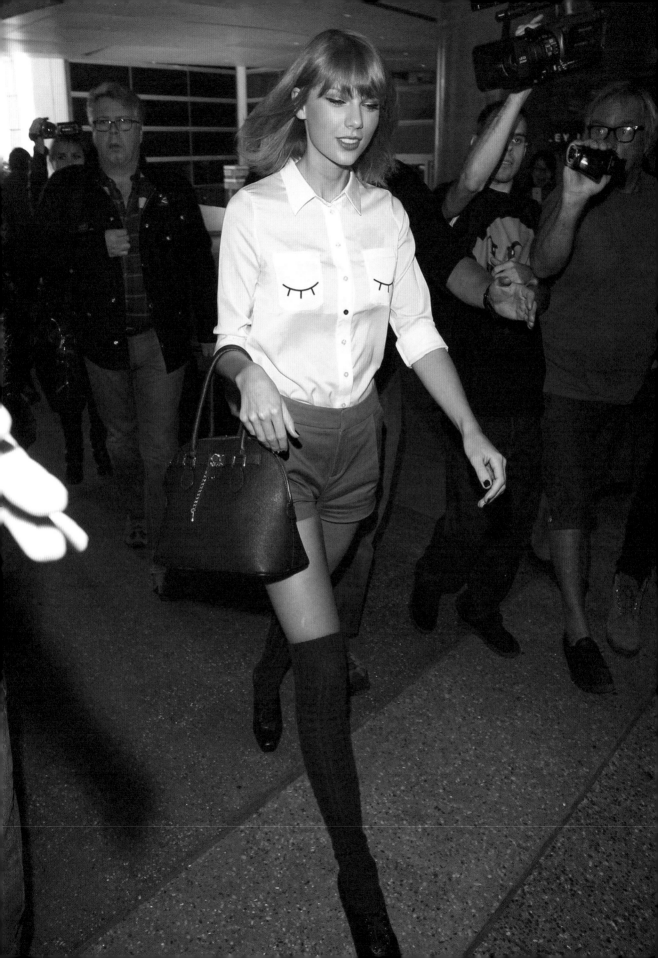

Taylor Swift
LAX, 2014

Whitney Houston
LAX, 1993

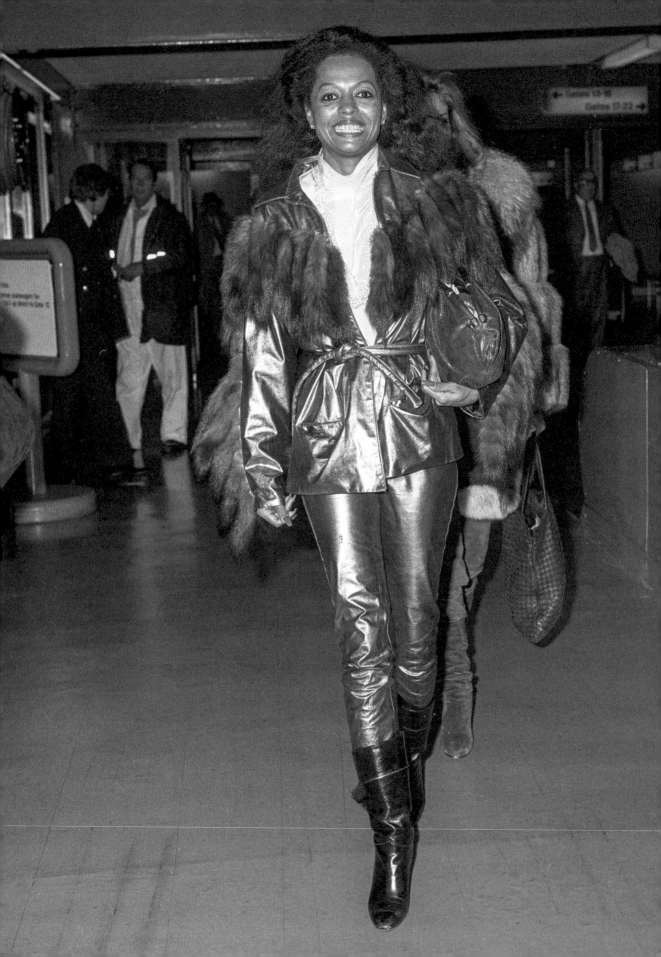

Diana Ross
LHR, 1986

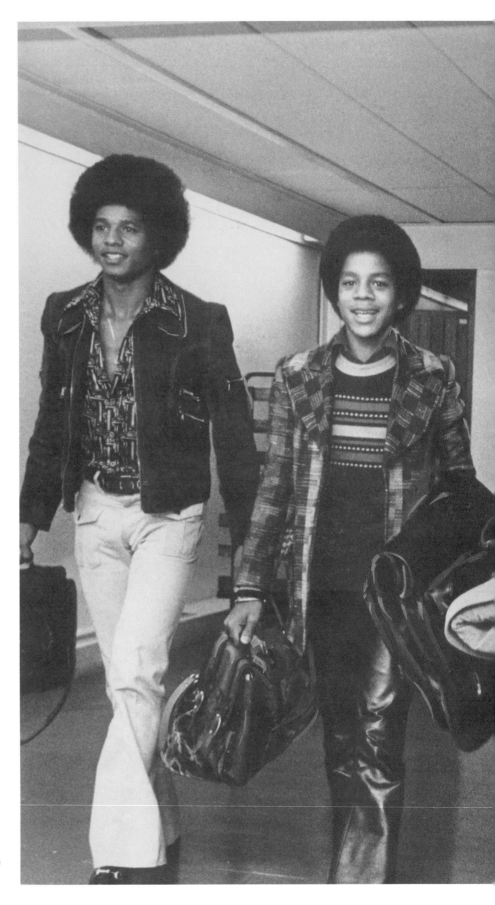

Jackson Five
LHR, 1972

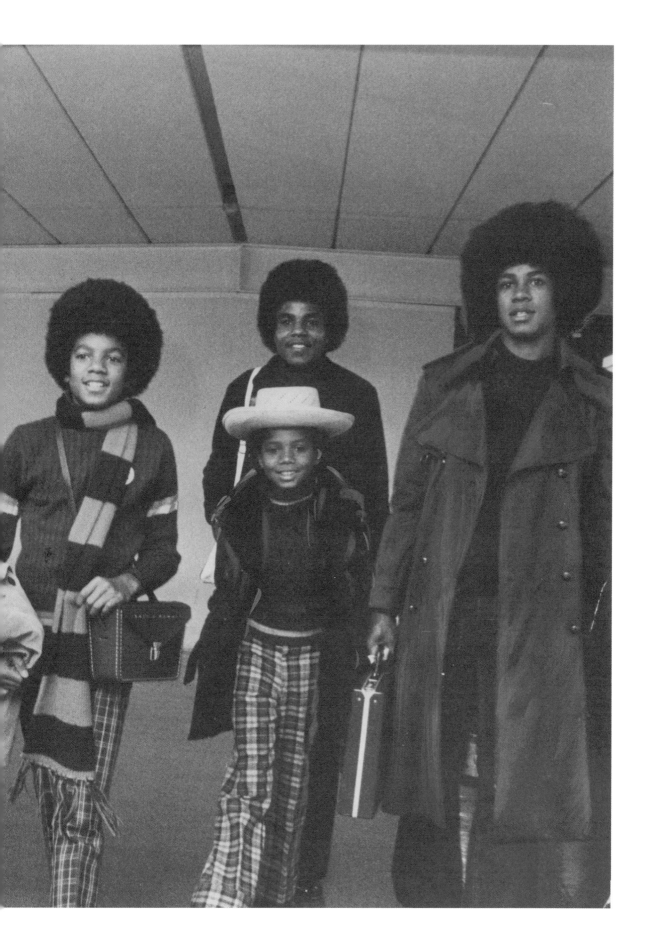

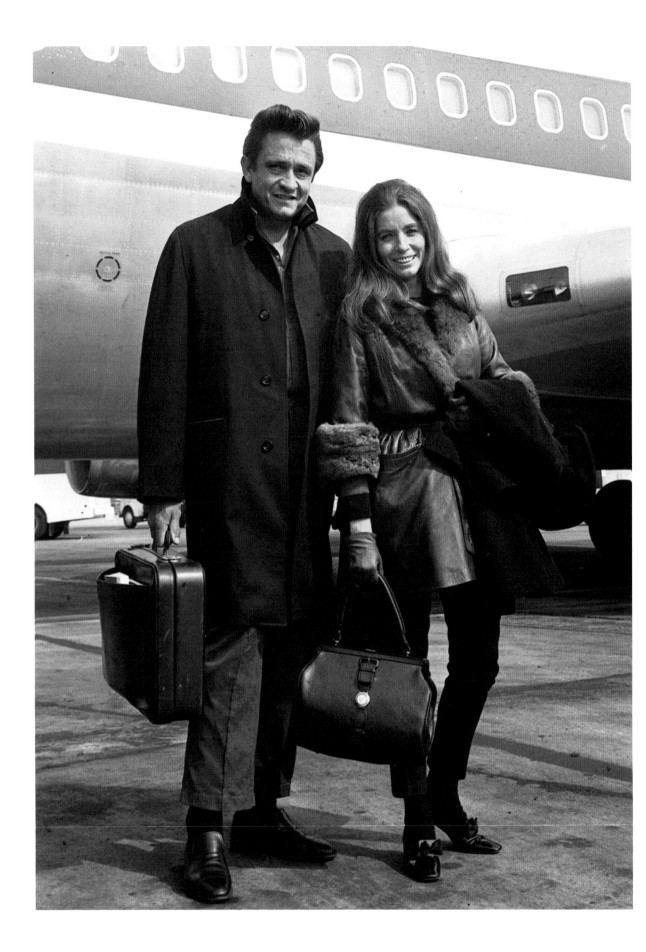

Johnny and June Carter Cash
LHR, 1968

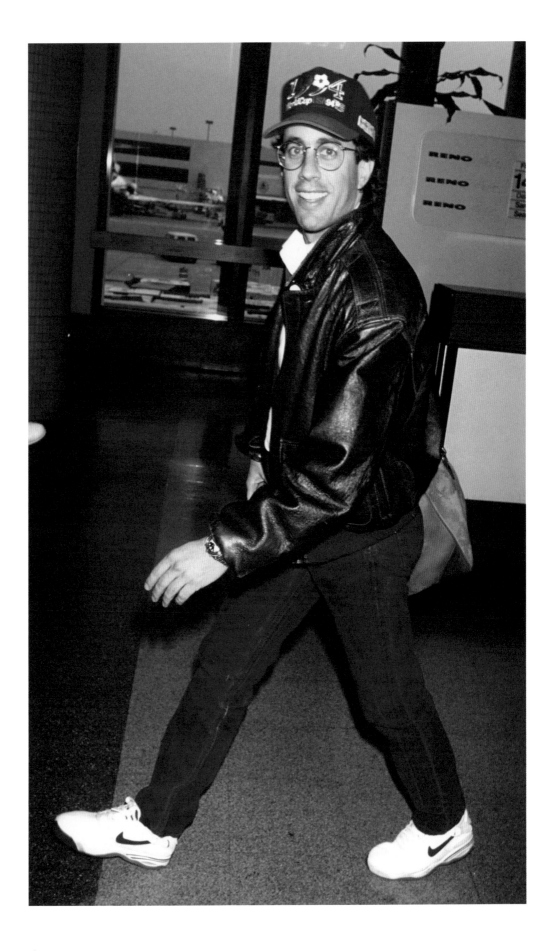

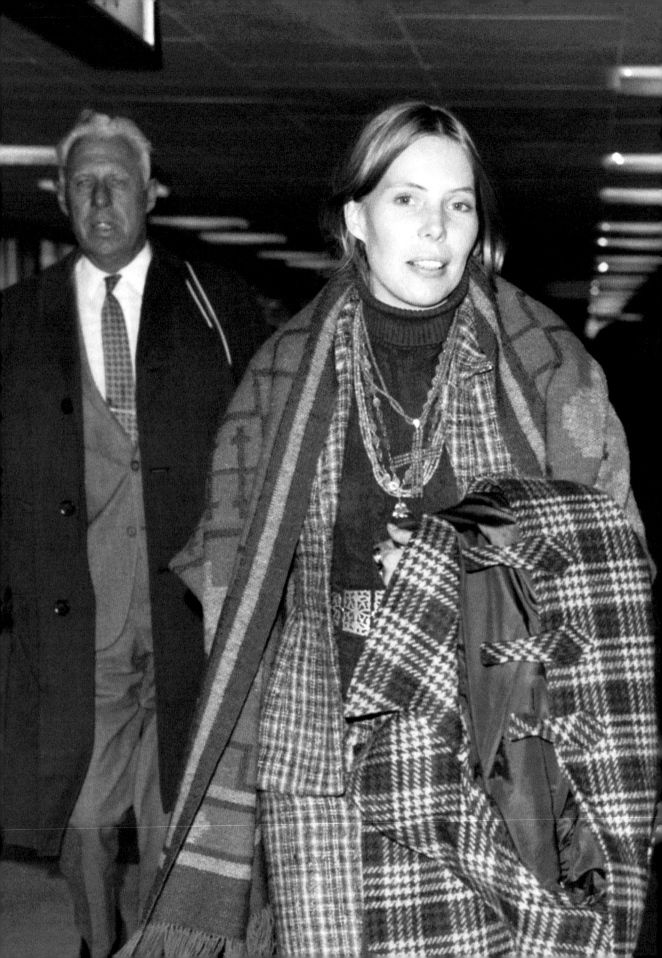

Joni Mitchell and Graham Nash
LHR, 1969

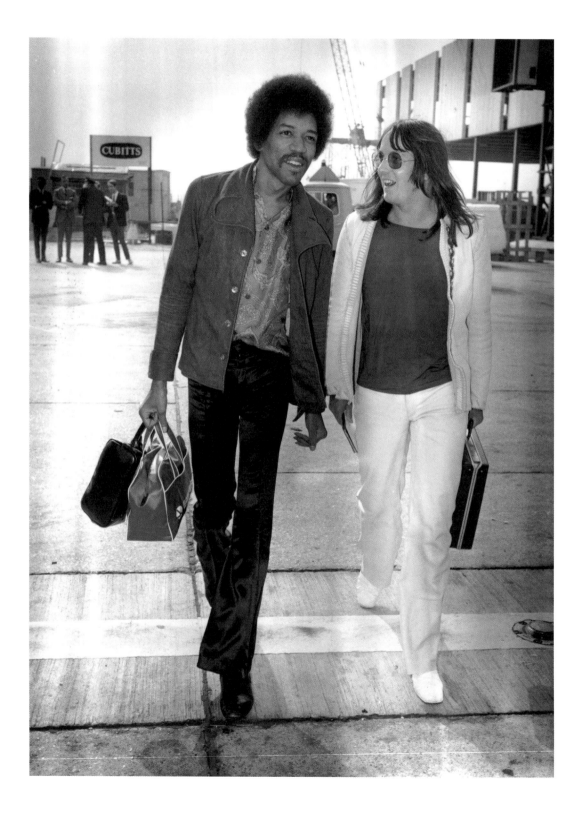

Jimi Hendrix and Eric Barrett
LCY, 1970

Twiggy
LHR, 1966

Maureen and Ringo Starr
LHR, 1970

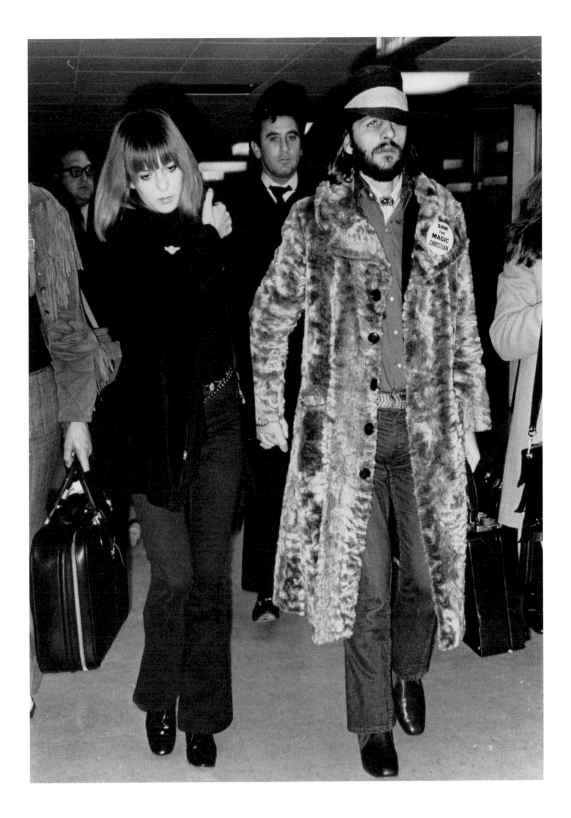

Any bag that's with me will take the same course as I will. It will take the same airplanes and will be squashed in the same way and will be used as a cushion in the airports.

—Jane Birkin

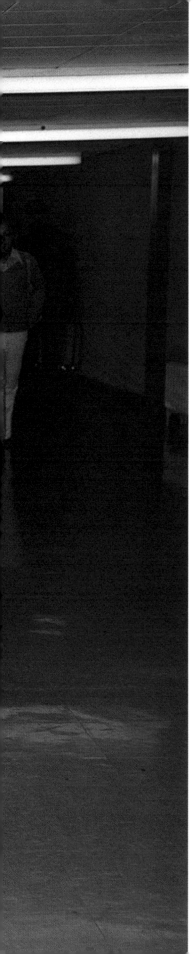

Jane Birkin and Serge Gainsbourg
LHR, 1977

Chloe Sevigny
NCE, 2019

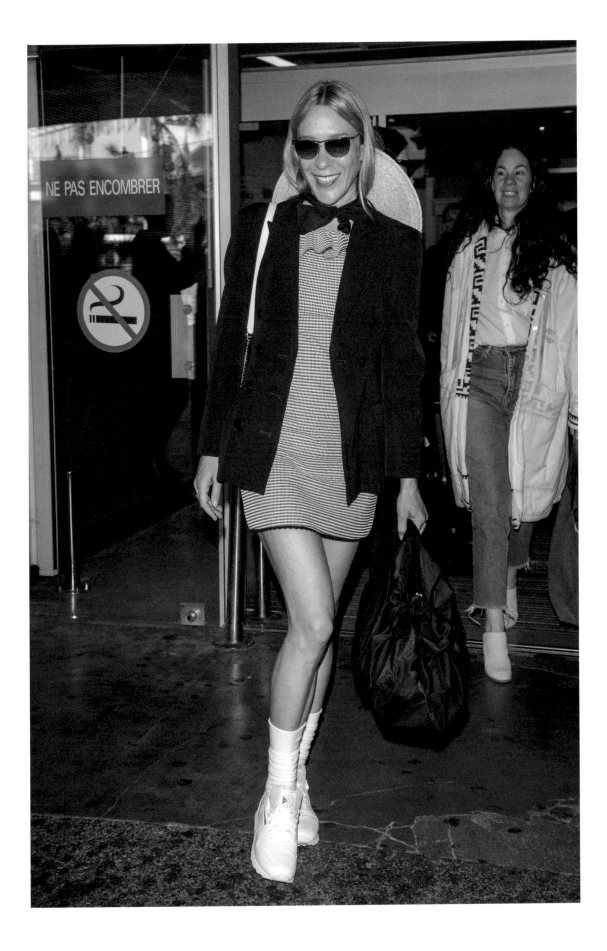

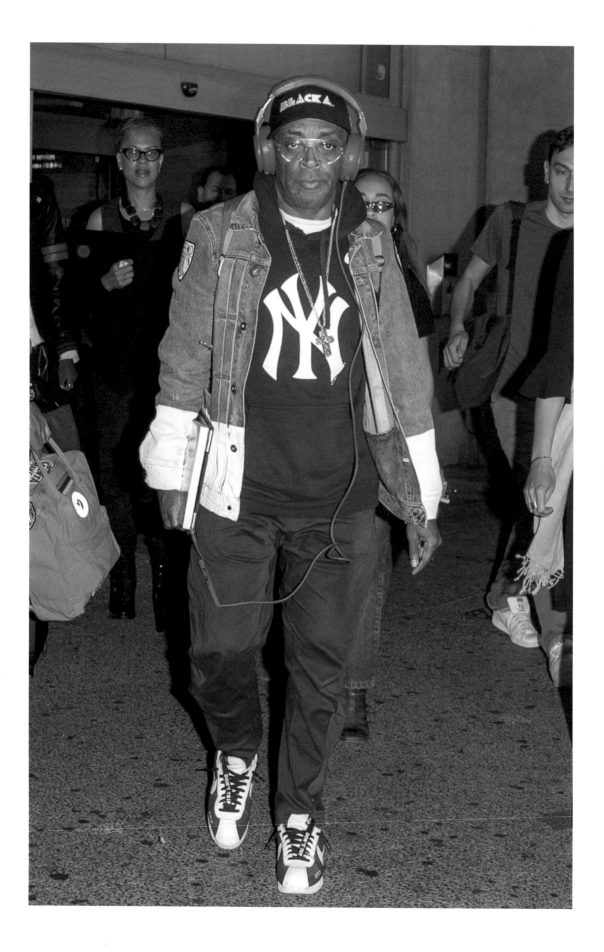

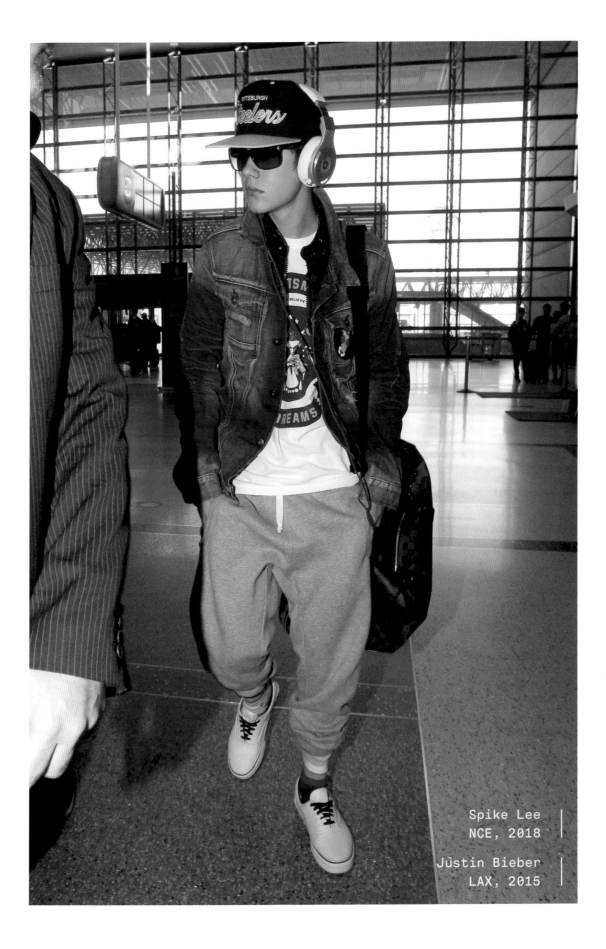

Spike Lee
NCE, 2018

Justin Bieber
LAX, 2015

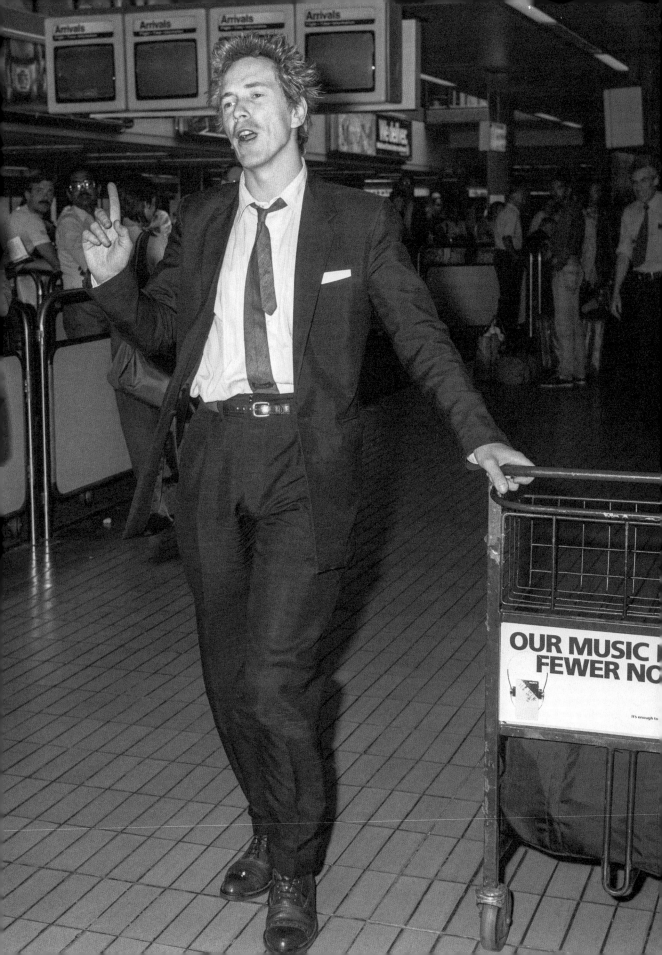

Johnny Rotten
LHR, 1987

I haven't isolated myself. I am not living on a yacht somewhere. I am not tucked away or behind a gate somewhere. I am not flying on a private plane. I am going to the airport.

—Nicolas Cage

Sharon Stone
LAX, 1997

Truman Capote
LHR, 1968

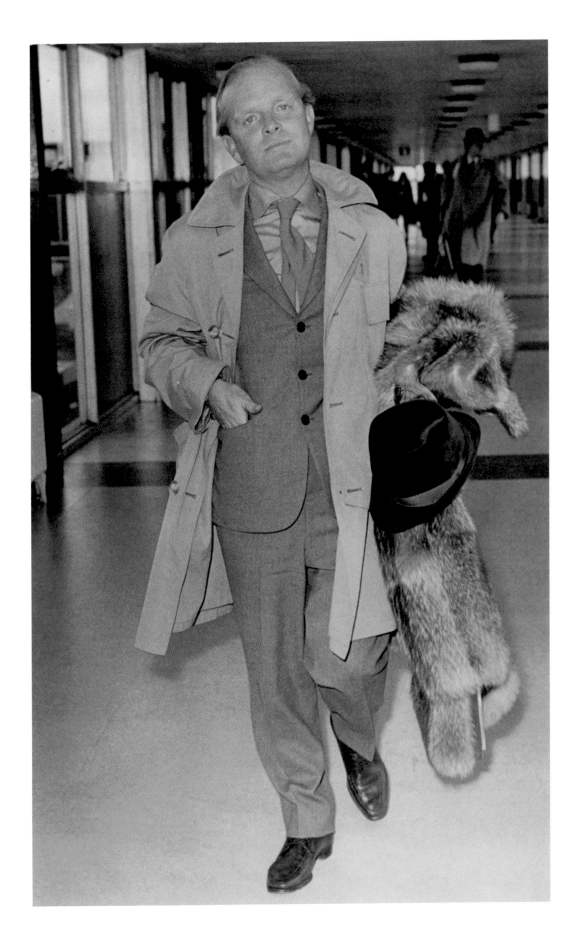

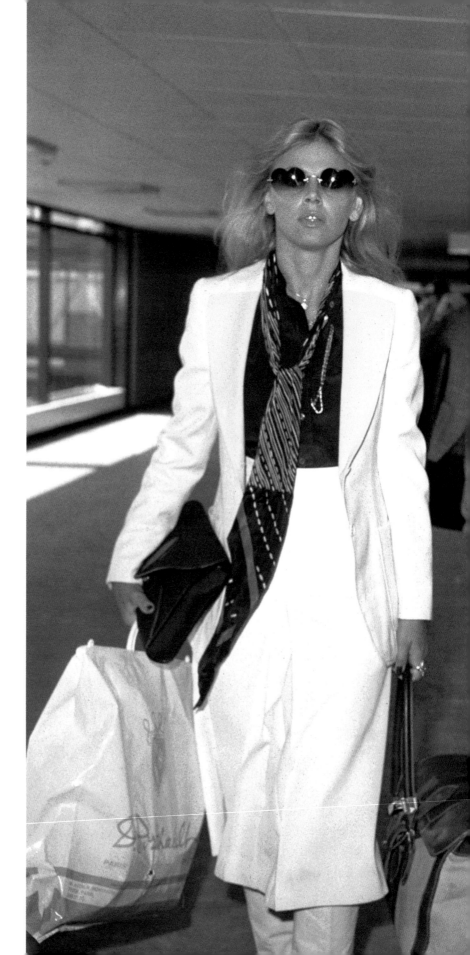

Britt Ekland
LHR, 1976

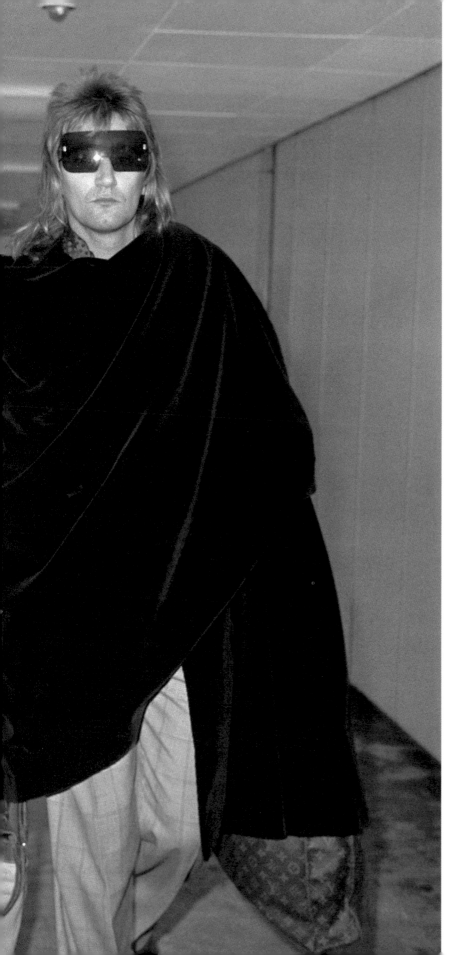

Rod Stewart
LHR, 1976

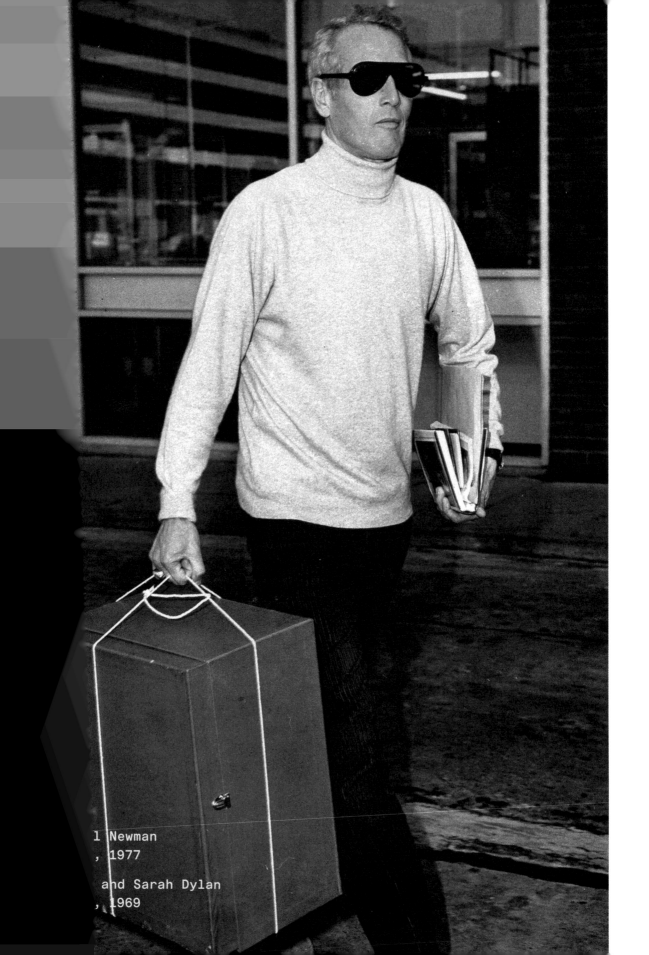

l Newman
, 1977

and Sarah Dylan
, 1969

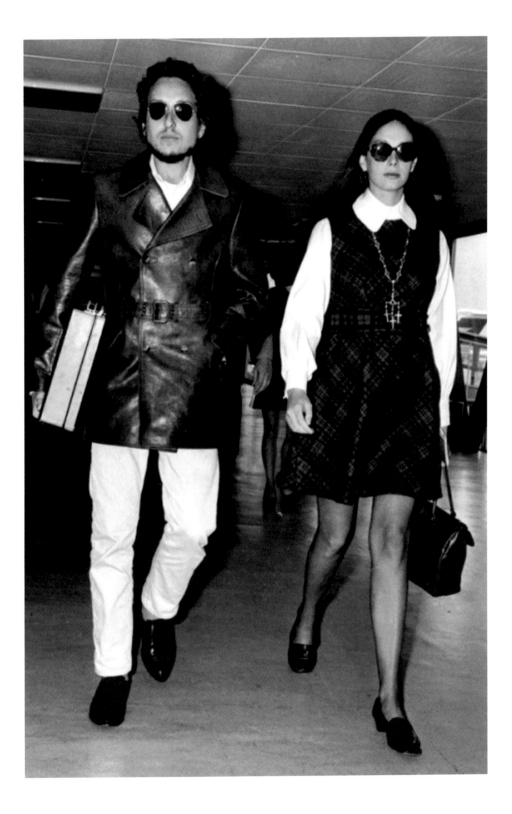

Erykah Badu
LAX, 2015

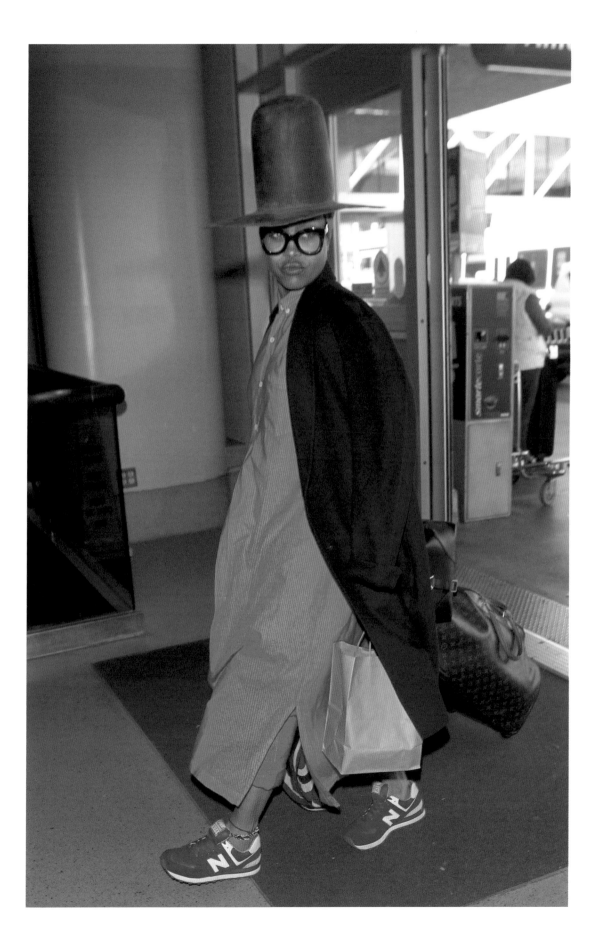

I personally go to the airport looking like a homeless person, because I think people will leave me alone. But I dress myself with my luggage—all my luggage matches.

—André Leon Talley

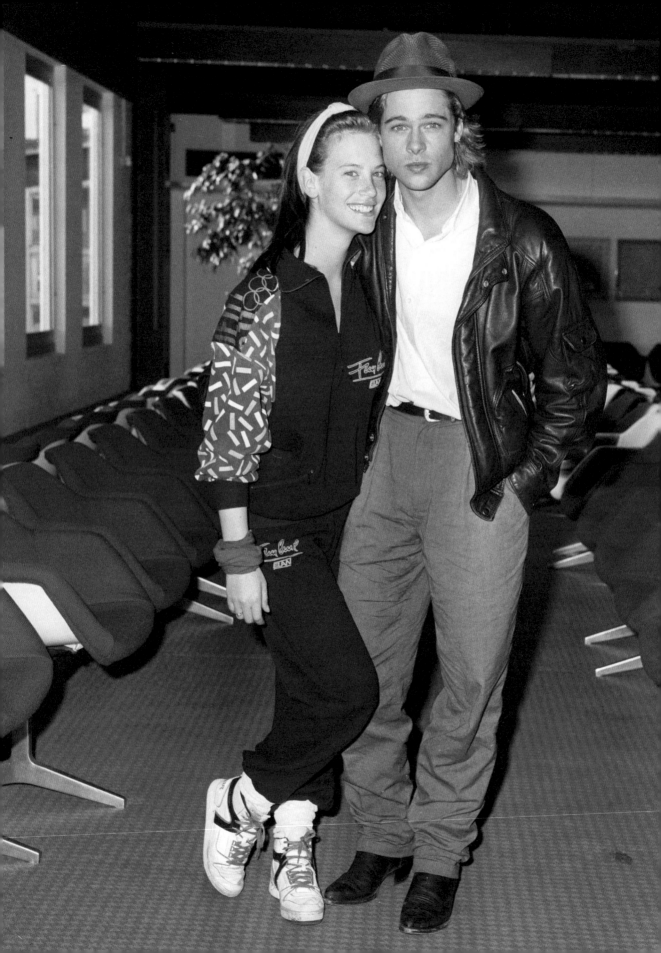

Cheryl Pollack and Brad Pitt
LHR, 1988

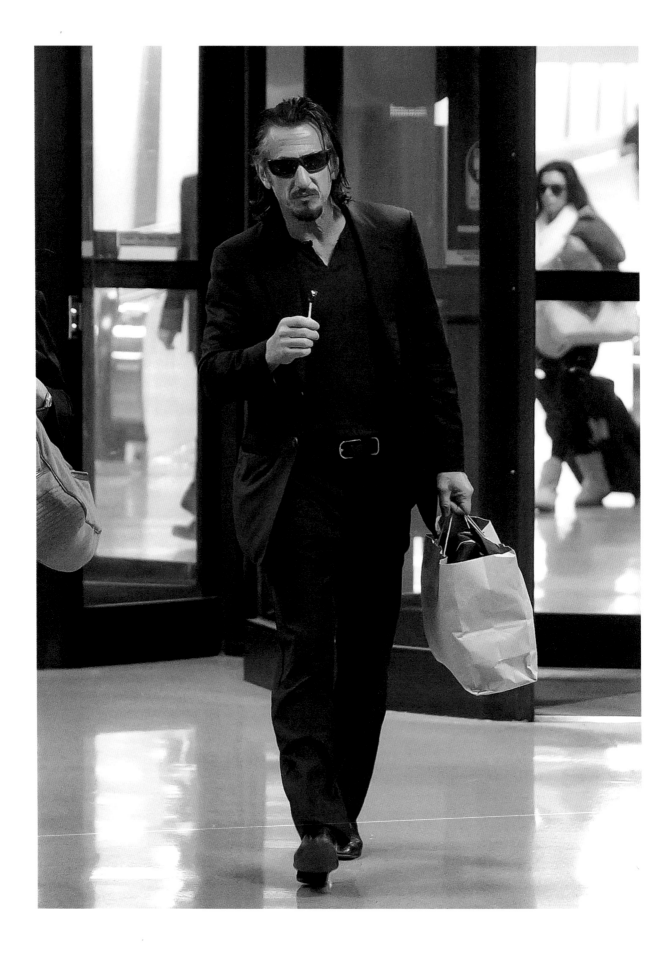

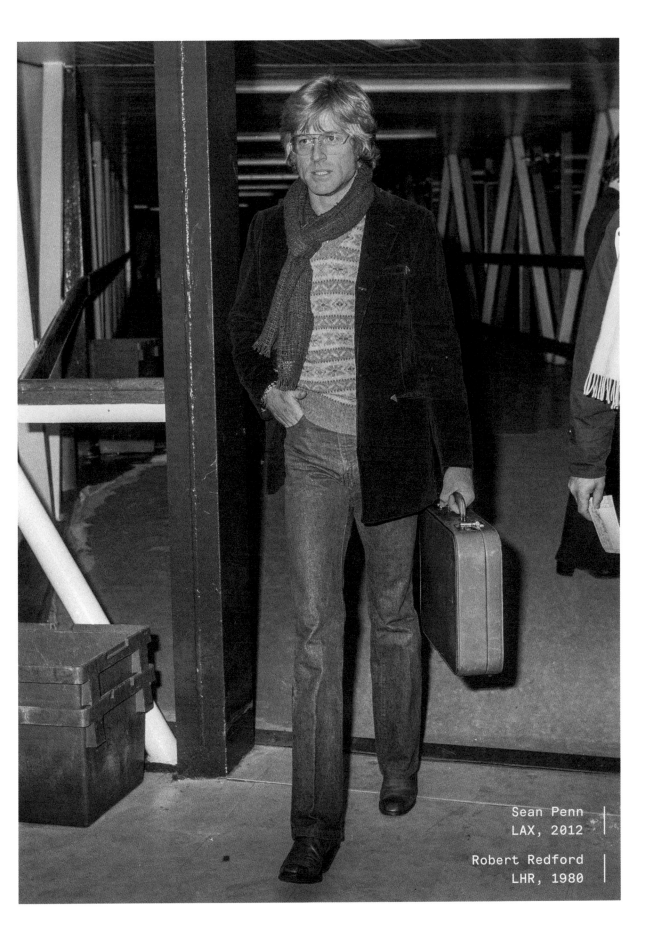

Sean Penn
LAX, 2012

Robert Redford
LHR, 1980

Sia

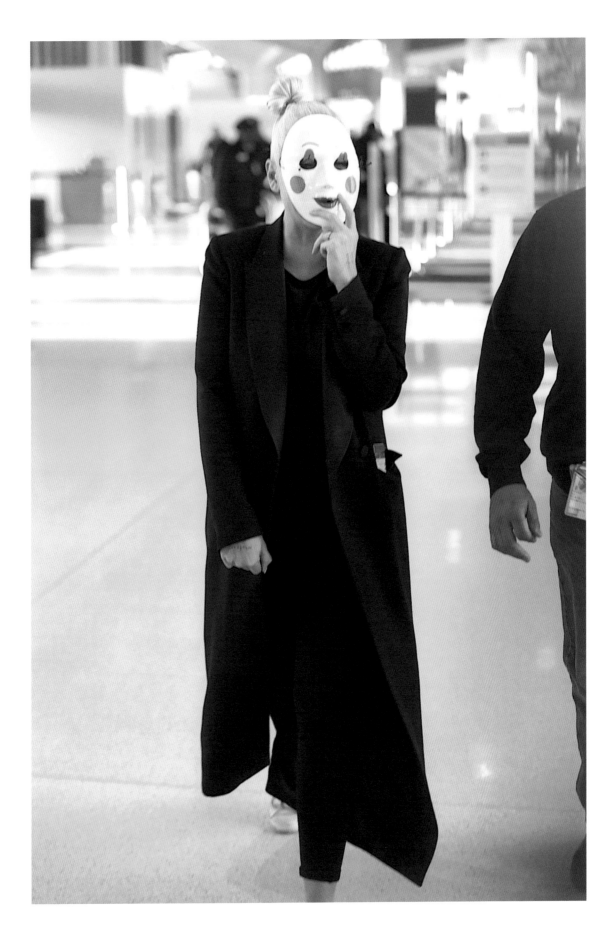

Sometimes when you go to the airport and look at the people, you see the worst looks—but the worst looks can give you more ideas than the best looks.

—Carine Roitfeld

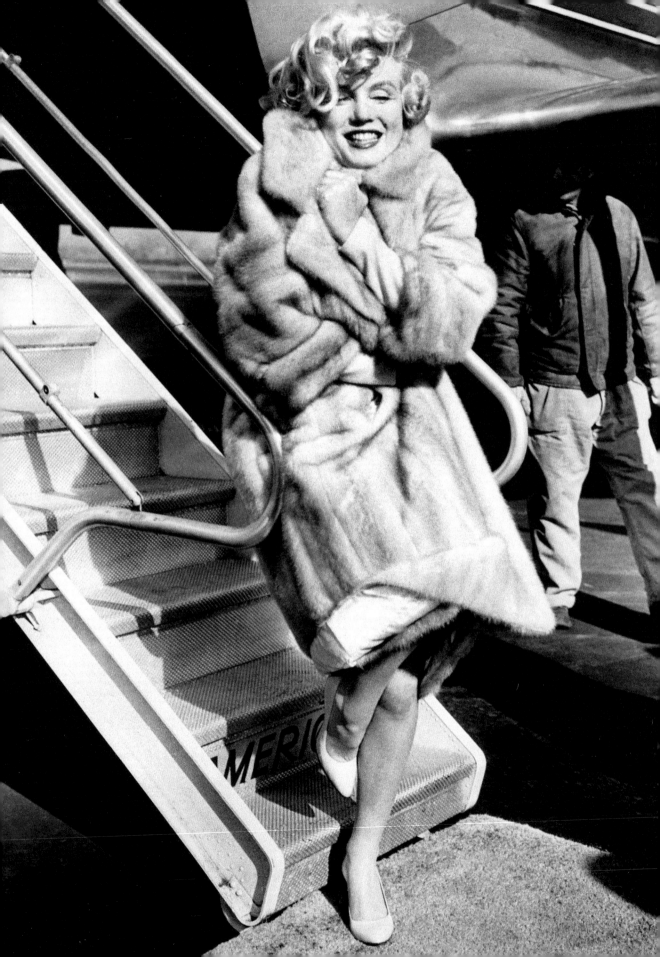